Carlos Frey

WATERCOLOR
THE CREATIVE EXPERIENCE

WATERCOLOR
THE CREATIVE EXPERIENCE

By

Barbara Nechis A.W.S.

PUBLISHED BY NORTH LIGHT PUBLISHERS/WESTPORT, CONN.

For Mal, Barry and Sharon

Published by NORTH LIGHT PUBLISHERS, a division
of FLETCHER ART SERVICES, INC., 37 Franklin
Street, Westport, Conn. 06880.

Distributed to the trade by Van Nostrand Reinhold
Company, a division of Litton Educational Publishing,
Inc., 450 W. 33rd Street, New York, N.Y. 10001.

Manufactured in U.S.A.
First Printing 1979

Library of Congress Cataloging in Publication Data

Nechis, Barbara.
 Watercolor: "the creative experience".

 Includes index

 1. Water-color painting — Technique. I. — Title
ND2420.N4 751.4'22 79-9334
ISBN 0-89134-021-1

Edited by Fritz Henning
Designed by Barbara Nechis
Composed in 10 pt. Optima
by John W. Shields, Inc.
Printed and bound by Halliday Lithographers
Color Printing by Federated Lithographers

Acknowledgements

I am most grateful to the contributing artists whose superb paintings and enthusiasm for this book have enriched both the content and the entire experience for me. The text has profited from the advice and encouragement of my editors Walt Reed and Fritz Henning. My special thanks to Ed Whitney who opened the world of watercolor to me, taught me the basics and ignited a spark. And to my friends, especially Marylyn Dintenfass who gave me feedback on every detail from day one through proofreading, Frank Webb for many suggestions, dozens of titles and careful reading, Diane Faxon for listening with interest and involvement, Fran Greenfield for care in photographing me in my studio, Michael Rossi for skillfully completing the diagrams, Mark Friedman for his thoughtfulness and generous contribution of photo equipment and information, and Jerry Lighter for giving me so much more to think about than I ordinarily would have. Ira Wunder (The Photo Loft) simplified the photography process for me and expertly printed the black and white photos.

Contents

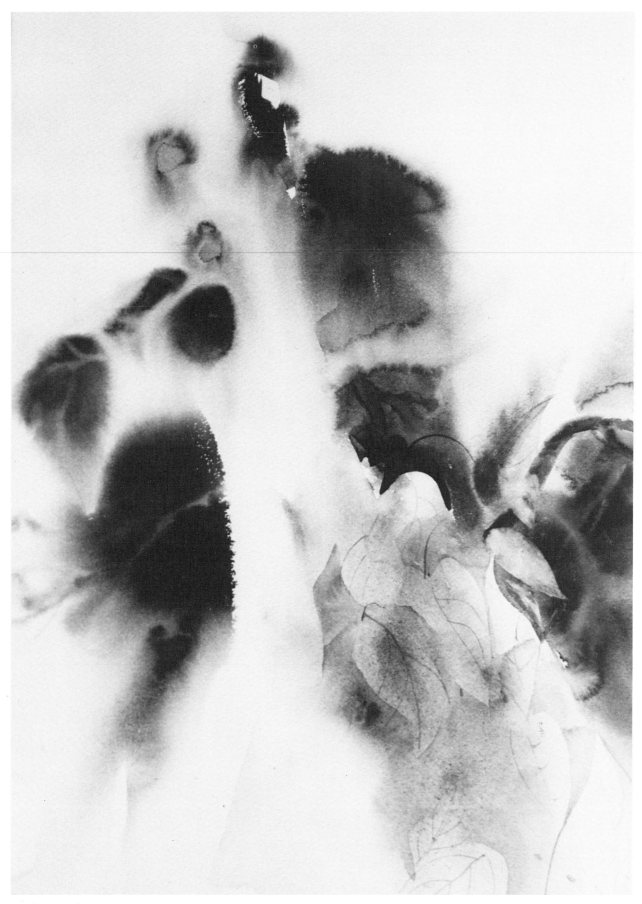

Leaf Cascade

Introduction

Twenty years ago I watched a classmate run a wash. It was my first introduction to wet-in-wet watercolor and I was seduced. Exploring watercolor has been a challenge ever since.

I can't think of a subject or technique that I have not tried, but basically I am interested in shapes. In these pages you will not find out how to paint a barn or a rock, wave or apple. What you will find is an approach to painting in which these objects appear, but are not the central focus. Many of the techniques demonstrated are versatile and can be used in describing a broad range of subjects.

Content and technique go hand in hand. One without the other produces either sloppy work or sloppy thought. Many good ideas have been ruined by limited technical facility, much of it through omission rather than lack of ability. The viewer of the painting should concentrate on the idea rather than the technique. The technique must therefore be flawless or it will get in the way of the content. For this reason, constant attention to detail and edges will help develop control so that spontaneous expressions become more than happy accidents, and original concepts develop into fulfilling paintings.

I still frequently work wet-in-wet with a direct approach. I have learned that the control afforded by other techniques refutes the common belief that you can't make corrections in watercolor. So, I often work from errors, making constant corrections, finishing my failures while retaining or even reclaiming freshness. The key to my work is looseness with control. Every edge is considered even when the effects appear to be spontaneous.

Watercolor is a medium which presents infinite possibilities. I choose to explore these possibilities, wherever they may lead, by refusing to restrict myself to methodical rules. I deliberately avoid the approach of painting specific things. There are numerous books available for those who wish to follow this approach. My purpose is to take an advanced student through my thought processes so he or she may develop an understanding of how to grow and how to use technical material in new ways. In this way the student should be able to apply what he learns and create his own personal statements.

Most of my paintings shown in this book were selected from previously painted works or they were ones in progress at the time of writing. More than half were demonstrations to show the kind of variety that comes from a constant search for new ways of presenting material.

Also included is the work of other artists whom I admire for their personal style and magical quality in conveying it. Selections were made to show paintings of outstanding quality and to illustrate a broad range of style and approach.

Chapter 1.
Materials

Basic Equipment

Portability is important to me as I teach various workshops away from home and frequently take concentrated painting trips. Although I am a devoted studio painter, my travel equipment and studio materials are one and the same. I have various lightweight boards in masonite, tile board, and .080 plexiglass — plastic used for framing instead of glass. All this material is thin yet strong enough to use as a rigid support for my watercolor paper. The paper is held in place with four metal clips. The support board, cut 1/4" larger on all sides than the paper fits in the bottom of my suitcase. I carry a John Pike Palette with each compartment completely filled with color so I can carry a minimum of tubes for a short trip. The palette slips into a plastic bag and is packed in my suitcase. If I must fill the palette just before going out, I place it, uncovered, in my unlit oven to set for twenty minutes. The warm pilot bakes it just enough to form a light skin over the paint so that the colors will not run together. The rest of my materials go into a tackle box along with my tube paints. Add two water containers, a plastic drop cloth for outdoor use, a roll of paper towels, and I am set.

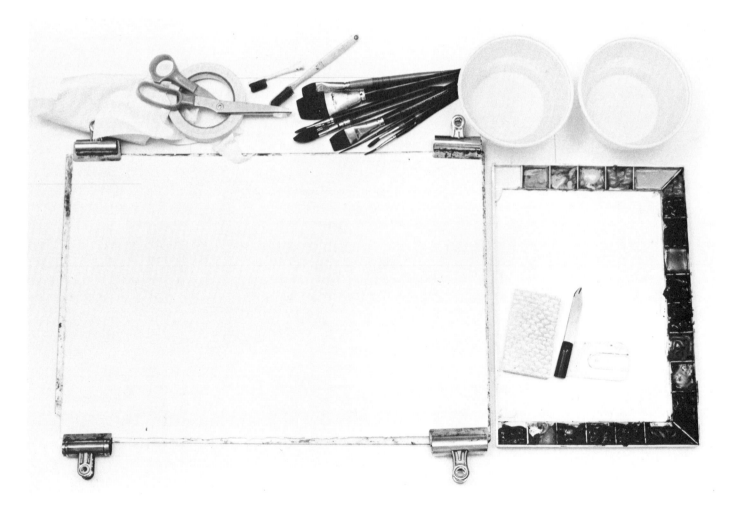

Paper

My paintings vary in style and approach and so my materials reflect this flexibility. I work in many ways and have developed few prejudices as to method of application or technique. Likewise, I have had excellent results with numerous papers, palettes, brushes and brands of paint. However, watercolor can be a difficult medium. Certain materials can minimize problems. Unless otherwise stated, all of my paintings in this book were painted on D'Arches 140 pound cold press. This paper can take a fair amount of scrubbing for correction, and its smooth but absorbent surface is ideal for fluid washes. Unfortunately, 140 pound paper is light enough to permit a moderate amount of buckling if it is not stretched (a process which is not dear to my heart). After a period of working on stretched paper, I gave it up feeling that the pleasure of using perfectly flat surfaces was countered by many drawbacks. As a reformed "paper stretcher" it is a joy not to hear paper popping in the night as it leaves the board. I do not attach much value to a sheet of paper. The time involved in the stretching process lends too much importance to a single sheet. If I start off badly, I can rush to the sink and wash off my "start" Several of these and I might turn the paper over and begin again. Some days I may do as many as ten starts, all of which have exciting possibilities. It may be as long as two years before I get some of these finished; a few may be completed within the week, and many others are discarded along the way. At any given moment there are at least a dozen paintings in my studio in varying degrees of finish. It's not convenient to accumulate large numbers of incomplete paintings stretched on boards. They take up too much room.

Other papers, less versatile than D'Arches cold press, can provide a good change of pace. Fabriano Cotton 140 pound cold press has a smoother less absorbent surface. Paint dries very quickly and often leaves brush marks and puddles. It is difficult to get a good graded wash on it, but clean strong darks are easily achieved. And scraping or sponging away paint produces clean sharp edges. Also, its quick drying time facilitates glazing. *Lindwood* (page 104) was painted on Fabriano. The whiteness of the paper is an asset in paintings with strong value contrasts.

Bainbridge Illustration Board Number 80 cold press has a finish which sets the pigment quickly but still has a moderately absorbent look. Overlays or glazes are possible almost immediately. *Landscape Levels* (page 50) was painted on this Board without pre-wetting. Wet effects were achieved by painting immediately into the still-wet painted shapes.

Hot-press surfaces are totally non-absorbent. They are ideal for ink, line, and paintings where crisp edges or scrapeouts are needed. The ink drawings (page 38) and *Monhegan Branch* (page 15) were done on Bristol Board which has a hot-pressed surface.

Rough paper is excellent for stressing texture. Graded washes take a little extra effort in that the white bumps of the paper tend to reappear unless they are strenuously covered. Snow and tree paintings can be quite successful. Unless handled expertly, paintings on rough paper can look so dry the viewer feels like coughing.

If you prefer to buy paper by the block, either remove it from the block, or loosen the sides and bottom to minimize buckling. I prefer the smoother side which is mounted towards the block.

Brushes and Tools For Applying Paint

A prospective student once called to inquire whether I use razor blades and other "gimmicks" in my work. Any tool can be used as long as it gives the desired results. I have painted successful pictures with cheap brushes and applied paint with many tools, but I don't like to be aware of many tool marks in a completed painting. Special tools can be helpful if not overused. They can also help in loosening up.

If I had to use only one brush, my painting would not change noticeably. Ninety five percent of my work is done with a 1½" sable wash brush. I bought it long before prices soared on sable, but would invest in it again today. An excellent substitute is the same size brush in either sabeline or white sable. It holds its edge beautifully, and will last a lifetime. My other favorites are: Aquarelles in 1", 1/2", and 1/4" widths, excellent for painting crisp edges; a #6 round for softening edges or where a square brush is not needed; and #2 and #4 long haired riggers for line and branches. Both habit and price have determined my preference for flat rather than round brushes.

Other useful tools are plastic (Not Rubber) bowl scrapers or credit cards for scraping away paint and printing lines; a very dull kitchen knife for scraping and printing finer line; sponges for printing texture and wiping away paint or excess water; salt, waxed paper, wax candles and plastic wrap for introducing texture; and several soft bristled toothbrushes for scrubbing out or spatter textures.

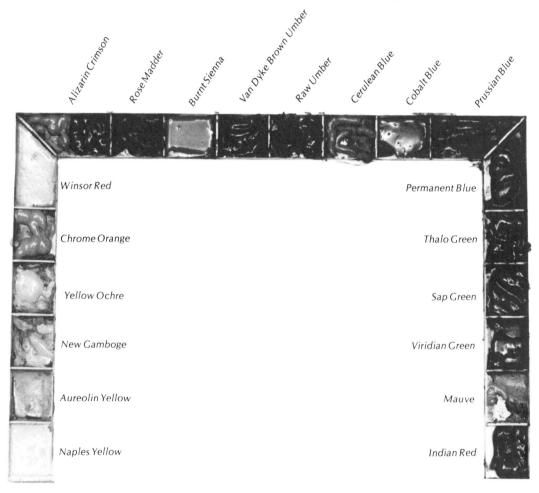

Alizarin Crimson · Rose Madder · Burnt Sienna · Van Dyke Brown Umber · Raw Umber · Cerulean Blue · Cobalt Blue · Prussian Blue

Winsor Red

Chrome Orange

Yellow Ochre

New Gamboge

Aureolin Yellow

Naples Yellow

Permanent Blue

Thalo Green

Sap Green

Viridian Green

Mauve

Indian Red

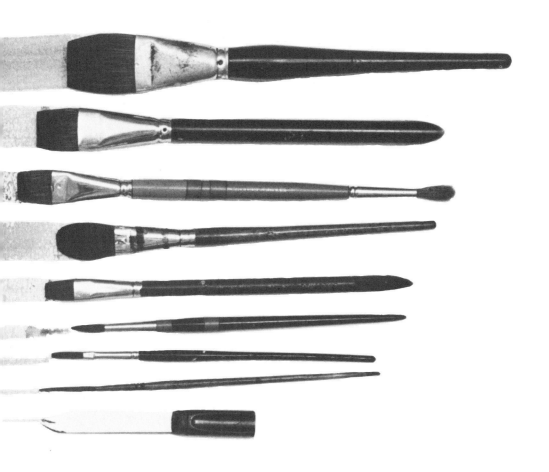

Colors

Here is where the fun begins. I can't remember a color I haven't tried or liked at some point. All that is needed for interesting mixing is a variety of warm and cool colors, both transparent and opaque. Unlike many painters, I do not stick to a limited palette. Exploration of a new color lends excitement and by varying my palette I avoid falling into the trap of sameness or cliches. For example, one compartment of my palette holds a cool red. It might be filled with alizarin crimson and replaced with alizarin carmine when it is used up. I usually leave several palette compartments for testing new colors. Also, at hand are additional globs of color on an extra palette which I may use when all the compartments in my main palette are filled. I make a conscious effort to try new color combinations although I seldom disregard completely some old favorites. I mix my own blacks and grays as I find they are livelier than premixed tubes. I usually mix grays from complementary colors because a two color mixture produces more transparent grays than a three color mixture. However, lovely rich grays are produced from balanced triads suggested by Barse Miller. He used three mixtures: 1 — yellow ochre, indian red, cerulean blue; 2 — rose madder, cobalt blue, aureolin yellow; 3 — Winsor red, yellow and blue.

Mixing and Special Color Uses

My choice of colors is listed on the Materials Check List. Choice of palette is very personal. Obviously, my color choice per painting does not use the full range, but the special properties of some of the off-beat colors would not be discovered without experimentation. For example, I often use opaques for special textures. Naples Yellow can be a superior substitute for Chinese White which looks dingy by contrast when white paper is also left exposed. Naples, or white, when mixed with any of the reds produces richer pinks then red thinned with water. Van Dyke brown is fugitive, but Van Dyke brown umber is a rich hue without that fatal property.

Sap green has more strength and life than Hooker's and mixes beautifully. The settling qualities of permanent, French ultramarine, cobalt and cerulean blue when mixed with sap green, ochre and other earth colors add rich texture and variety to washes, especially pleasing in small areas.

Materials Check List

Paper

D'Arches 140 pound cold press (my personal choice)
(It is more economical to buy by the quire — 25 sheets 22"x30")

Brushes

1½" wash brush (sable, sabeline or white sable preferred)
1" and 1/2" aquarelle (3/4", 1/4", and 1/8" optional)
#6 or larger round sable (only sable will hold a point)
#2 and #4 riggers (long haired brushes for line work)

Palette

John Pike (my choice) butcher's tray, white ceramic plate, glass or tile

Colors

Winsor and Newton Artist Grade Colors (my choice)
Permanent Pigment Student Grade Colors (an excellent choice)

Naples Yellow (Win. Newton)	Cerulean Blue
Aureolin Yellow (Win. Newton)	Manganese Blue
New Gamboge	Cobalt Blue
Yellow Ochre	Prussian, Thalo or Winsor Blue
Cadmium or Chrome Orange	Permanent or Ultramarine Blue
Cadmium or Winsor Red	Thalo or Winsor Green
Alizarin Crimson	Sap Green
Burnt Sienna	Raw Umber
Van Dyke Brown Umber (Perm. Pig.)	

All are not necessarily on the palette at one time. Other colors sometimes included are Chinese White, Cadmium Yellow, Chrome Yellow, Indian Yellow, Vermillion, Rose Madder, Brown Madder, Sepia, Raw Sienna, Hooker's Green, Mauve, Ultramarine Violet, Dioxazine Purple (Perm. Pig.), Viridian Green and the Acra Reds (Perm. Pig.)

Tools

Dull Knife	Cosmetic Sponge
Plastic Bowl Scraper	Kitchen Sponge
Credit Card	Blotters
Serrated Plastic Knife	Paper Towels
Razor Blades	Water Containers
Wax Paper	Plastic Drinking Straws
Wax Crayon or Candle	Toothbrushes
Salt	Scissors
Plastic Wrap	Masking Tape
India Ink	Metal Clips

Painting Board

Support boards should be cut 1/4" larger than the paper on all sides. Masonite is excellent but tends to warp. Tile board is an improvement. Plexiglass is excellent.

Working On Location

A habit I have acquired is painting with comfort. This is my first requisite. I will always sacrifice the view for personal convenience. I have painted inside my cabin only steps away from a superb view, to escape the wind or sun, both of which are fatal to the control of edges because they make the wash dry too fast. I tend to become sloppy and uncaring when forced to contend with discomfort. Therefore I'll spend enough time to locate a comfortable location. I prefer to work on an open porch. Then I am not separated from my surroundings and enjoy an overhang as protection from sun and rain. I also bring along a folding table so that I can work standing with my supplies at a convenient level. This amount of equipment means that I cannot travel far from my car, to follow country streams and rugged trails with my paints. I use my sketch-book, camera, or memory of impressions for this job.

I once worked for a week on an open porch in Maine, with my back to the sea and my paper held close to the cabin in shadow rather than in sunlight. People in the area questioned my position. They could not understand why my back was toward the view until I explained the need for shade. I was probably the only visitor who loved the mist and foggy days because the colors sang against the grays and the watercolor drying rate was optimum. When the sun came out and the sky turned bright blue, the colors seemed ordinary by comparison and I had to hunt for shade.

Another pitfall of location painting is missing the forest for the trees. I spent a week's vacation painting on Monhegan Island and readily fell into this trap. I was so impressed by the charm of the village as seen from my Inn, that I immediately began a large painting including the graveyard, trees and all buildings in my line of vision. Three days later I was frantically finishing windows and chimneys, furious with myself for having wasted half of my precious vacation on a boring painting that was becoming an obsession. I finally put it aside and captured "A Quiet Place." (page 48). Although the large painting took much of my time, I developed the practice of doing small watercolor sketches each evening in the hour before dusk. Monhegan Branch (page 15) was one of that series. It was painted on Bristol Board, and was more satisfying than my major effort.

To avoid the trap of wasting time on the wrong picture you should let the feeling of a place seep in before beginning to work. Your first burst of enthusiasm for the locale may be misleading. This attitude was reinforced when I visited Reuben Tam's studio. There were no paintings of shacks to be seen. This fine painter and teacher does not find it necessary to paint things, only their essence.

Monhegan Branch
12″ x 16″
Collection of Vibeke Garde Jorgenson and Frank Burford, New Rochelle, New York

Painted on Bristol Board with a large brushstroke. The paint was scraped away and dragged with a scraper to form the dark branch above. A rigger was used to paint the dark curves in the main branch. The painting can also be used as a vertical with the left edge becoming the top.

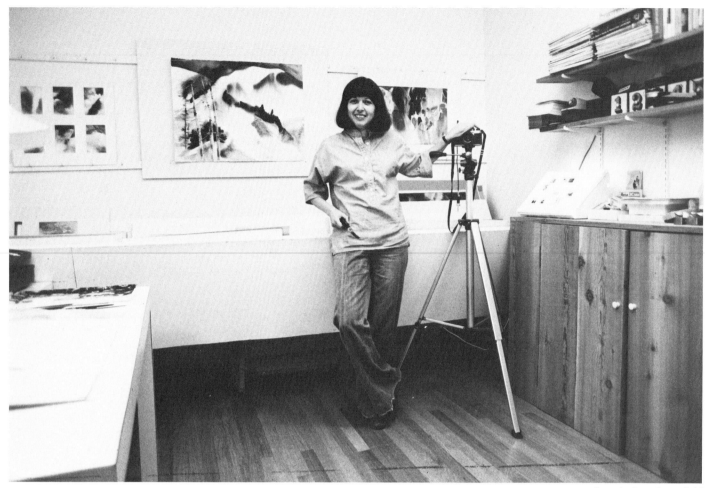

photo by Fran Greenfield

Studio Setup

A place to work is essential and can usually be found despite adverse circumstances. I have always kept a space for my own work so that I could readily make use of short blocks of time. My first studio was a hall closet. By removing the sliding doors, putting in a formica counter balanced on two bookcases, arranging shelves for supplies with bulletin boards on either side, I was in business. Fresh paper was always clipped to my board and a filled palette ready to open at a moment's notice. The convenience of this small space was something I didn't want to lose when I moved to larger quarters.

Now I have a large teaching studio with a dozen doors placed on saw horses for table space. I work here constantly, utilizing all of the tables and even the floor for my progressing pictures. Much of my time is devoted to studio painting. I also have a small studio with bins for matted work, record files, a mat-cutting set-up, table, and duplicate painting supplies. I often walk in to straighten up or find something and then spend much of the day fixing or finishing paintings. I also have a photography setup here, with light stands, tripod, and a system of clipping work to the wall for proper photographing. Lighting in both studios consists of color corrected fluorescent bulbs to approximate daylight. Again, the closet doors have been removed and a counter set in as a mini-studio for writing.

Reference File

A morgue will grow very quickly and before you know it you will have an unlimited source of material for inspiration and for problem solving. I started saving interesting clippings, Christmas cards, etc., without being aware that I was starting a reference file. This brown bag of clutter grew and I was finally shamed into organizing a more respectable file. A few copies of ski and sailing magazines gave me a wealth of beautiful snow and water photos. A friend asked to borrow them and positively hooted as I dumped out my brown bag and shuffled around until they were uncovered. Embarrassed by my visible lack of organization, I sorted the pictures and placed them in an accordion envelope file. As the material expanded it was filed in separate manila envelopes, each labeled according to subject, as an invaluable reference source for me and for my students.

I also keep a separate file for reproductions of other artists' work such as original greeting cards, magazine reproductions, and exhibition announcements which include photos. The original reproductions are helpful for stimulating ideas and comparing a variety of styles, but copying from this file is discouraged. Copying can become a crutch and retard the development of designing ability which will grow through constantly creating, discarding, and learning from errors.

Occasionally the file is used when a painting is partially finished. I will search through and find a few clippings that echo parts of my subject, and which may turn up a solution or direction to follow. Students are particularly encouraged to use the crib file for technical information. How is a tree planted? How are the branches attached? How does a roof overhang? How can you add a porch to a building? Which is the widest part of a boat? What does a lighthouse look like? Flower and seed catalogues, the New York Times in general and its travel section in particular, and many magazines are great resources. The free newspapers in various resort towns often have excellent photos of the local landmarks or landscape. Black and white photos are particularly helpful in encouraging the development of personal color statements. Magazine clippings in color can stimulate original ideas about how to use color. Such information can often be applied to a variety of subjects.

Basic Materials for the Beginning Student

I want to stress this point. It is more important a beginner use the materials recommended than a professional. Experienced painters can compensate for poor quality paper and brushes by perfect timing. They know how much water or pigment a surface requires at a given moment. A beginner needs all the help he can get. In the interest of economy, use a white dinner plate for a palette; buy only one brush (a good one is essential, probably the 1″ aquarelle); make sure your paper is of the highest quality and use the other side if side one is a failure. D'Arches 140 pound will take much punishment and correction in addition to giving predictable results. Some of the methods described in this book will not work on lighter weights or other kinds of paper.

Chapter 2
Beginnings

A blank sheet of white paper is clipped to my board and I am immediately faced with decisions. What can I say on this surface? Being a coward and wanting to avoid disaster, I learned early on to let that white paper make a few decisions for me. First, by dipping it into my pool of water or wetting one side with a large brush and plenty of water, it is instantly wet. This gives me several advantages. Paint applied to wet paper can be easily removed. The wet paper also promotes a flow of its own. By following the unexpected, it designs for you. My basic method varies, but I usually clip my paper to a masonite board with 4 clips strong enough to hold the paper without distressing it. The clips are readjusted when necessary to eliminate paper buckling. By painting to the edge I have the option of using the deckle and mounting rather than matting the finished painting. Mopping the wet paper just under the edges with paper toweling, prevents oozles and crawl-backs at the edges. Sponging is avoided so as not to disturb the paper surface or sizing. This helps the illusion that the paint has floated on the paper.

There is a certain logical order to any process. A painting book usually begins with a listing of materials, and goes on to explain how to use them. Yet, how can one paint before knowing what to say? In a way, the order of this book is very much like the order in my work. I rarely begin with a design, drawing or concept. I just begin. When I plan a painting thoroughly, by the time I have captured it on paper, not only is some of the spontaneity lost, but the designs never seem to be as interesting as in those which I struggled to complete. Design is the most important element in painting, but I will discuss it in the following chapter. Here, I will start a painting so that there will be something to design or redesign. I tend to start by following the paint, working as far as I can; then I stop and begin to solve some of the problems I have created.

After the paper surface is wet, the first step is accomplished by loading a large wash brush with color and flooding it on the paper. I work in a range of either warm or cool colors in the background, with small passages of opposites for contrast. Often larger areas of gray are used to set off the color. I start with the lightest and brightest hues. At first I concentrate only on covering the paper with pleasing color, tipping the board for blends, throwing water on to help the flow, and leaving plenty of white spaces. It is a good practice to cover the whole sheet before it starts to dry so that there are mostly soft edged shapes and very few hard edges that may be distracting later on. It is easy to create a hard edge at a later point and difficult to get rid of one. While the paper is very wet it should be checked for a variety of values. A few wet, strong, dark areas will lend excitement and possibly suggest a theme or subject for the painting. If the choice of color is not a happy one, a fast squirt with the garden hose or the shower will make the paper ready for a fresh start.

How To Rewet Paper

One of the most frequent errors made by inexperienced painters in watercolor is that of being controlled by rather than controlling the wetness of paper. Beginners tend to assume that they are working on wet paper throughout a painting simply because they thoroughly wet the sheet at the beginning. However, the last section painted will look scruffy if not watched, because the paper is often dry by the time you get to this area.

Suppose three-fourths of your painting is finished and the remaining area has dried. If you rewet just this area, a crawl-back will be created at the edge where the painted area, now in the damp stage, meets the newly wetted area. Only if the painted area is still quite wet can the dry area be rewet so the two areas will blend together without problem. In order to create a wet look in the new area and avoid both a crawlback or a seam, you should thoroughly dry the paper. Then rewet with a clean brush and clean water both the area to be painted and enough of the previously painted area so that the new paint will not run as far as the edge of water. If you have an edge such as a building, this would be a logical place to stop. The edge of water over the painted area should be blotted with a tissue until the edge is invisible. If the water is not perfectly clean, an edge will show. To avoid this problem completely, you can rewet the entire paper and proceed to paint as though it had never dried. When working with full sheets it is nearly impossible to keep large areas wet for the time needed to complete the painting and several rewettings may be necessary. Remember that pigment placed on wet paper becomes lighter as it dries. If the color and value look correct while wet, add a little extra pigment to compensate for fading.

Textures

Texture often occurs early in a painting and can provide the spark of an idea which may be further developed. Varied effects are obtainable by manipulating papers, brushes and other applicating tools. Although too much reliance on techniques can make a painting look gimmicky, using them appropriately adds interest.

Salt

The main problem with salt is that it is overused. I've seen exhibitions where several pounds of salt must have been sprinkled into the paintings by the artists. The effect often looks good and it's easy to use. Unfortunately, so many people use it and the results are similar. The three paintings of mine shown below and on the next two pages demonstrate how the salt technique has been used in diverse subjects and picture concepts. In each case the salt was sprinkled on the wet paint, allowed to dry then brushed off.

I usually use table salt and pour a small amount in my hand to toss onto the paper. Kosher salt will produce larger granules for a slightly different effect. The ideal time to apply salt is when the paper is wetter than damp and drier than soaking. It will only work on wet pigment. The effects will appear softer where the paper is wetter, and more granular with individual "snowflakes" more visible when the paper is closer to the damp stage. Contrasts are obtained by using salt on both pale and darker valued areas. Be aware that salt will absorb pigment when it is wet and leave white spots behind. It will never absorb paint that has previously dried and been rewet.

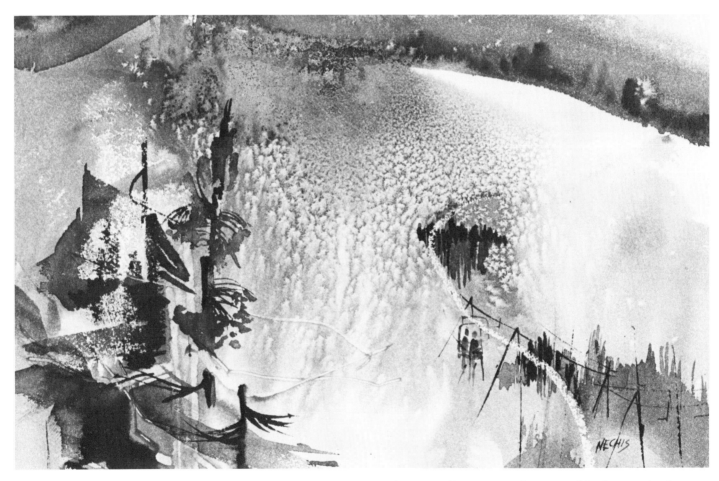

Lift Line
9" x 15" Private Collection

Table salt was thrown at an angle on the wet paint creating the texture in the snow. The variety in the texture oc- curred because of the shotgun effect of throwing the salt. A dense pattern of crystals hits the paper first. As the distance from the hand increases the more open and scattered the pattern becomes. After the area had dried, a candle was rubbed over the bottom left area and a thin line repeat was put in for balance on the right. The wax caused a snowy effect when spruce trees and a wash to create a ski trail were added.

Variations on Salt

Apply a varied value wash on wet paper. Toss salt, both table and kosher on both light and darker areas. Dry thoroughly and brush off all excess salt. Rewet either the whole or parts of the paper and flow on pale values of color so that some of the salted areas are tinted, and some are left white. Then add a few stronger values to an area which has not been previously treated with salt, allow it to come to the proper point of wetness, and salt it. Re-dry and remove excess. Now you can compare the various salt effects. Remember to remove all salt from both brushes and paper when you are finished so that it will not continue to act on your materials. Caution! If salt remains on the paper, a humid day can cause it to release moisture, resulting in new, damp rings. (Other examples of salt texture are in "On The Rocks" (page 64) and "Yellow Birds" (page 67).

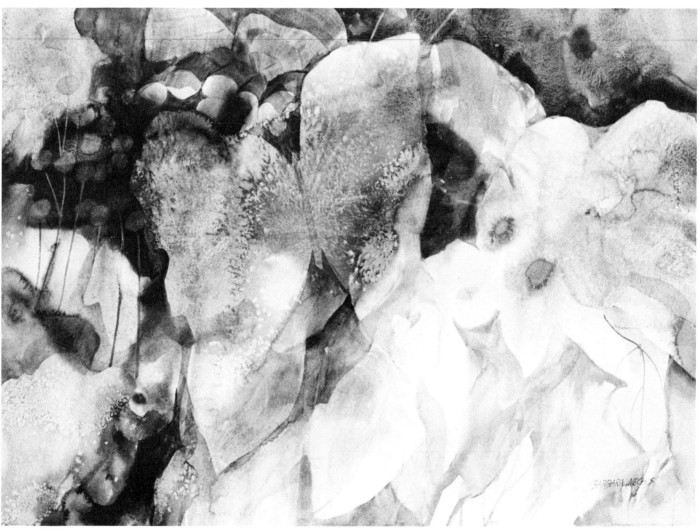

Winged Thing
22" x 30"
Collection of
Mr. and Mrs. S. Solon Cohen,
Boca Raton, Florida

This is an extremely complex painting involving many techniques. The salt was used early in the painting for textural interest. Originally, the butterfly was a series of caladium leaves. My daughter saw the butterfly in it when the painting was almost finished and I decided to change the leaf shapes into the butterfly by glazing and washing out areas. "Winged Thing" was painted on a roll of D'Arches 140 lb. paper. Roll paper has a harder, less absorbent surface than D'Arches purchased by the sheet. It tends to buckle and puddle more, but is very effective for glazing and wash out work. Most of the areas where salt was applied were reglazed in pale pinks and yellows to add further interest to the texture.

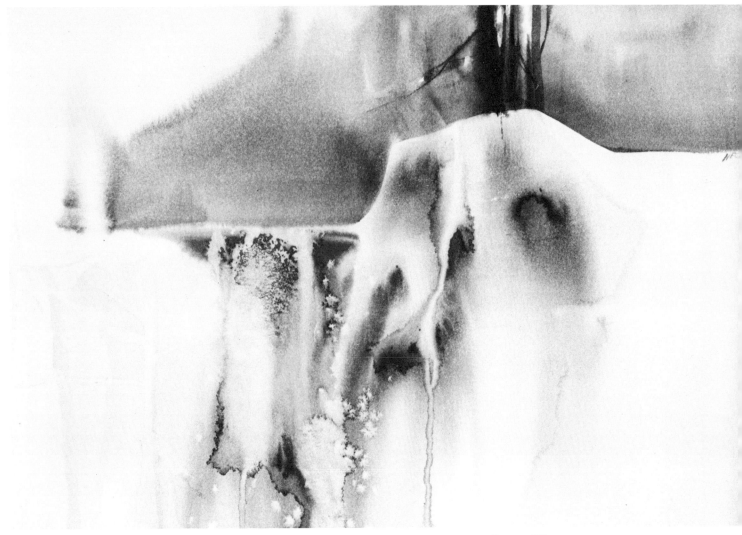

Frozen Water
15" x 22"
Private Collection

Salt, oozles and drips capture the interest. The upper background was painted last. The paper was turned upside down, the sky section rewet, and the paint flowed on. The background acts as a foil for the strong foreground and repeats the oblique shapes.

Salt pattern with glazed shapes

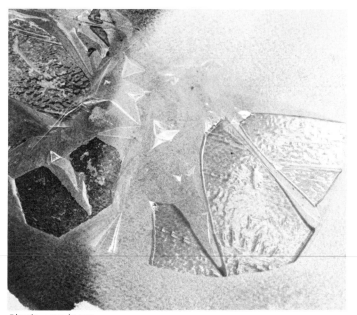

Plastic wrap in use

Texture created by plastic wrap

Plastic Wrap

For a unique texture, apply a sheet of plastic wrap to a freshly painted area and press it into the paint. Various shapes can be created by pressing down the crinkles. The folds of the plastic can be controlled by applying pressure. Allow the paper to dry thoroughly and then peel off the plastic. The result is quite decorative. I have used this procedure to create an illusion of fabric and pattern on plates and vases in still life. My students have created butterflies and landscape effects using this technique. Use caution and don't overdo it. Mono printing such as this can become a gimmick giving similar results to all users. It is easily detected as a trick unless you use it creatively and incorporate it carefully into your painting.

Spatter

This is one of the most valuable techniques because it has so many uses. The most obvious is texturing of dry paper to create a feeling of ground or almost any object found in nature, i.e. rock, trees, old boards, sand, stucco, snow, etc. Another use is to create variety. Smooth and textured areas will complement each other. Shapes can be emphasized by texturing. However, I find that spatter techniques are often most useful at times when they may not even be detected by any but the most astute viewer. This is to create value and color changes in areas that may have begun to dry. As anyone who has advanced to his second or third painting has found out, it can be fatal to paint in damp areas. The rings created by my oozles (an effect we'll consider shortly) were deliberate, but nothing can be more frustrating than to decide a mo-ment too late that your sky wash needs a drop- more color in one area. The brush is applied and a ring created for eternity. The best rule is to start at the top, paint in your sky, and leave it (taking care that water containers are placed beside rather than above your painting, to prevent accidental brush drips). When completely dry the area can be rewet and a second wash applied to correct the values. However, if the correction is small, and the paper still somewhat wet but too close to the damp stage to take a chance, a small amount of spatter to tone down a value of color will blend in beautifully. This can also be done when an area is bone dry. The drier the area, the finer the spatter will be. I always use a very soft toothbrush with close nylon bristles because it is easy to control. First I wet it, then scrub it in the color I wish to use, then tamp it over my water jug to release the excess water. Finally I hold it a few inches above the area to be treated, bristles down, and run my thumb briskly through the bristles. This will be done several times until the correct value is obtained. If a color needs to be muted, the same thing can be done using its complement. Notice the color changes produced by spatter in Karen Butler's painting (page 85). The left area is very simple but the spatter texture adds enough interest to balance the more complex areas.

Clear water or Chinese white can also be used as spatter to texture a painted surface for snow, surf spray, or any light effect. I often use scraps of paper to cover areas and create shapes, then spatter away at the uncovered portion. If the spatter is too defined, it can be softened by dragging a damp brush across it or by spattering water over the area immediately before it dries.

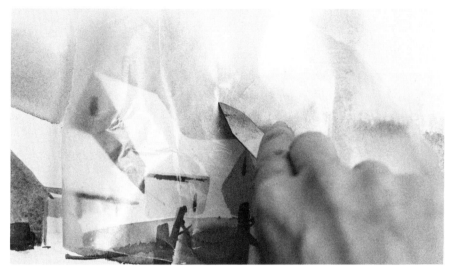

Waxed paper and knife technique

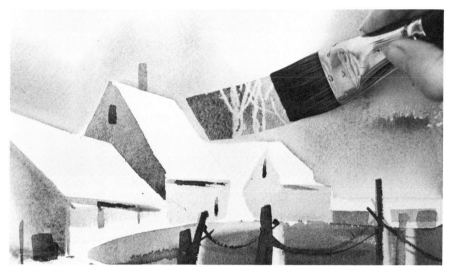

Brush stroke over wax drawing

Ripped paper towels covering areas to be protected from splatter

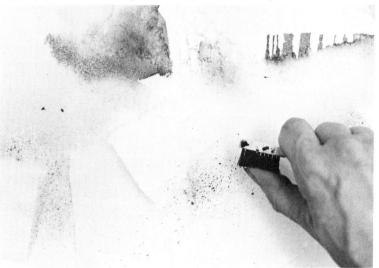

Foreground shows spatter; Branches in background left drawn with wax. The house was scraped out and painted around. (Note the sponge print on house.) Upper right background texture created with salt. →

Wax

If you like surprises, you may enjoy this technique. Run a wax candle or pale crayon over areas of dry paper you wish to texture and then proceed to paint. The wax resist will create a textured area. I have used this method for snow paths, snow capped mountains, trees, and sheeting rain or snow. The major drawback is the lack of control and difficulty in removing the wax if you change your mind about an area. An interesting way to use wax is over a previously painted area. When the area is repainted the first layer shows through where the wax coating has protected it

Waxed Paper

There are some practical uses for this technique which I discovered quite by accident. I was attending my first watercolor class and the project was to paint six sky washes. The foreground painting would be done later. I was terribly pleased with one of my stormy skies and terrified to mess it up by ruining the foreground. I decided to sketch some trees on tracing paper and lay it over my painting before making a final decision. Since I had few supplies, I improvised with some waxed paper on hand. I laid it over the painting and drew. Liking the design, I then wet the paper for painting and discovered the resist. I painted the area and ended up with an effective silhouette of white trees. This technique can be used for all kinds of thin light line, by drawing on the waxed paper with a dull knife. Adjusting the blade angle produces thicker or thinner lines.

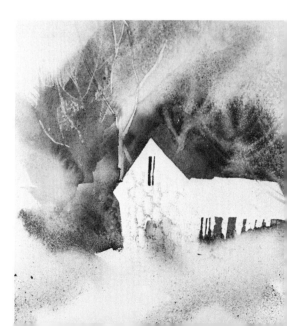

Oozles

This is a word I use for an effect discovered by accident. With refinements I have developed it as a major theme for a series of paintings. "Saxon Wood" (page 99) is the best example of it, and "A Quiet Place" (page 48) is the painting that first employed it. Here is how it goes: Lay your paper flat, wetting it thoroughly with a brush so that the surface is gleaming wet. Now combine two pigments on it with opposite properties, one transparent, and one opaque. The transparent paint flows through the opaque quickly due to the very wet surface, while the granular pigment remains in the center of the ring created. Permanent Blue is my favorite sedimentary color, which is varied by coupling it alternately with Alizarin Crimson, Van Dyke Brown Umber, or Burnt Sienna. These unusual blobs placed at random on the paper give me ideas which are then worked into a total design. As they begin to dry, tilting the paper in various directions will cause an edge to creep around some of the blobs, as the wet pigment collides with the drying paper. The areas first painted hold their shape and color as they begin to dry, while the last areas are still wet enough to run. In this way variety is attained by the contrast of oozles next to runny wash.

Flower Mood
15" x 22"

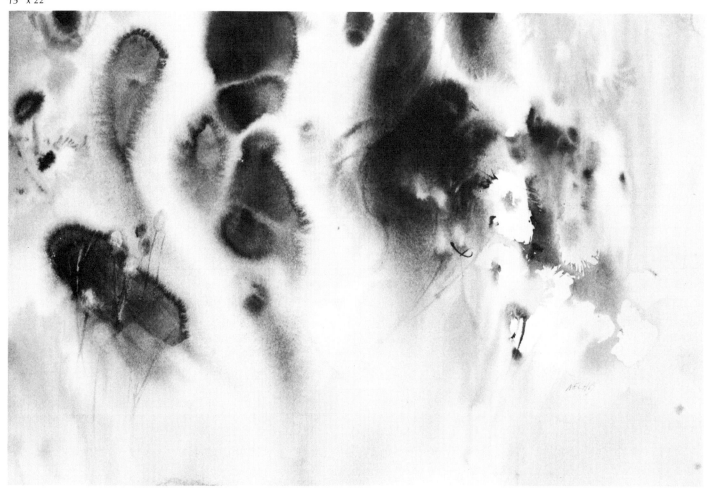

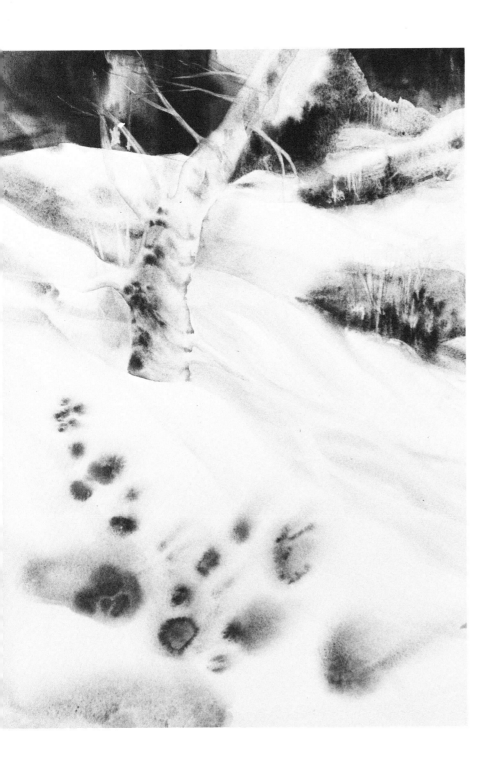

Winter Footsteps
30" x 22"

The oozles reminded me of footprints in the snow. They were the first marks on the wet paper but the decision of painting a vertical did not come until later. I repeated the oozles up the side of the large tree for unity and used a sponge to wipe white shadows in the snow. I deliberately broke up the dark shape at the top of the page so that it would allow the white of the trunk to combine with it. If the dark was continuous, the white trunk would appear to split it and would be too aggressive. This painting was in progress for two years. I cared a great deal about it because I was using the only piece of Whatman Board I have ever worked on and the soft surface was lovely. The paper was a very strange gift. I scout out IBM flip chart cartons to carry framed half sheets. This single sheet of mounted Whatman was found in a discarded IBM carton. How it got there I'll never know.

Wet Line Drawing

The most difficult thing to learn in watercolor is judgment of how wet, damp or dry your paper is. Certain effects can only be obtained when the paper is damp, and since this is a fleeting stage, there is a strong temptation to overdo it when the paper conditions are just right. Practice and self discipline will allow you to make the best use of this delightful but fleeting step.

Take a long thin brush, dip in water, and proceed to draw on damp paint. Distant trees, branches and various lines will appear soft and white or frost covered when done this way. They will be more controlled on minimally damp paper. Rivulets over a stream bank or linework in an abstract could be other uses of this technique. A larger brush or very damp paper will cause a more "oozle" appearance.

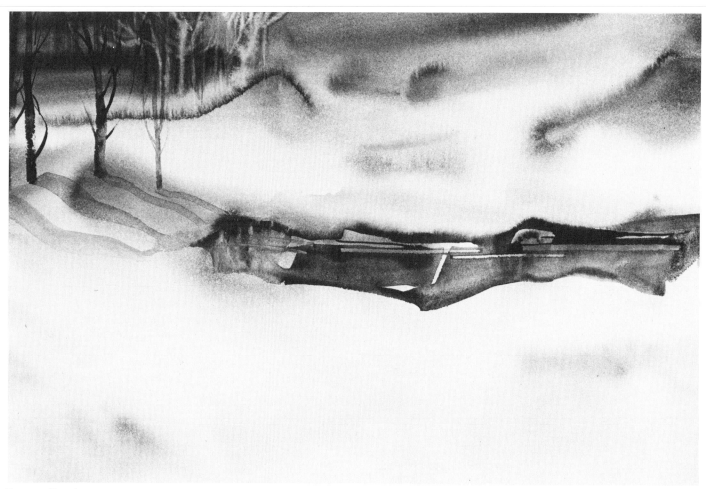

Frozen Pond
15" x 22"

Oozles and wet-line drawing form the swirling background and tree silhouettes. The light against the dark background suggests dusk. The pond and trees with shadows were painted after the paper had dried and a few scrapes were immediately put in as reflections, or marks in the ice.

Example of wet line drawing over stripes of pigment.

Larger wet line shapes.

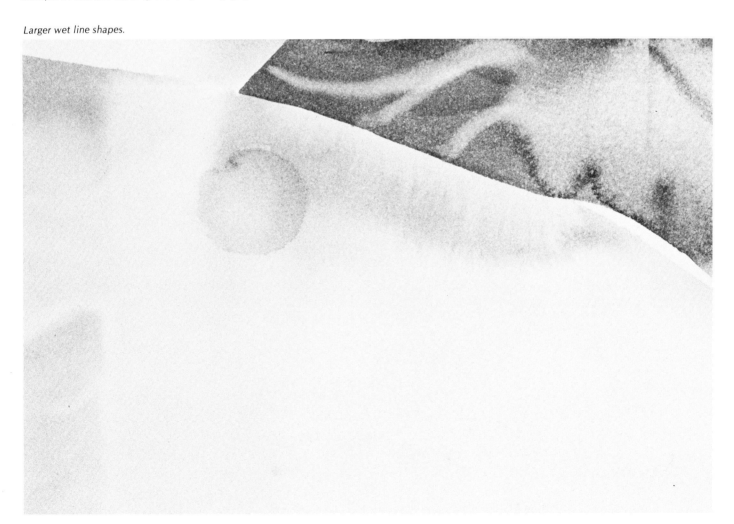

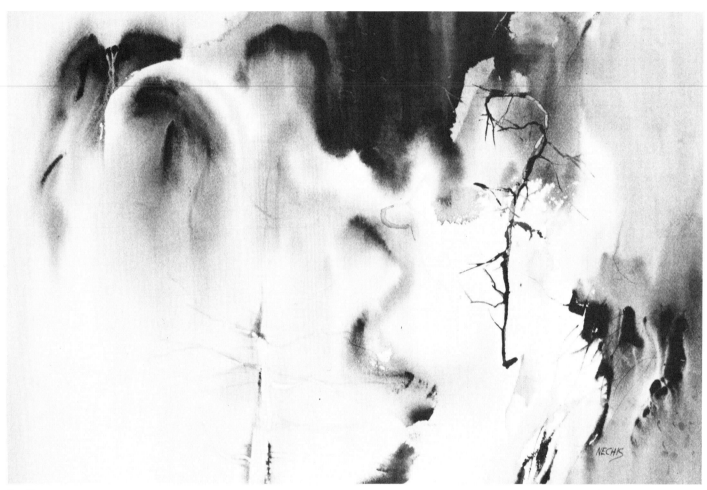

Sapling
15" x 22"

Sapling was started in the upper left corner and I proceeded clockwise. I had intended the first few strokes to be the center of interest, but changed my mind as I worked. I accidentally dropped my brush handle in a glob of wet paint and applied this directly to the lower right area. The last area painted was the hint of trees scraped into the lower left. Without them, this quarter of the page was cut off and empty. The Sapling itself was caused by seeing a drip about to run and guiding it with my fingernail into the shape of a tree.

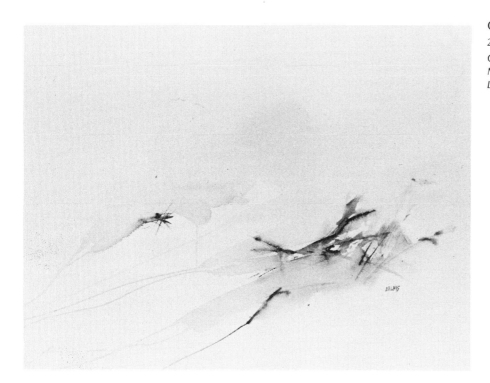

Grasshopper
22" x 28"
Collection of
Mr. and Mrs. John P. Laudenslager,
Larchmont, New York.

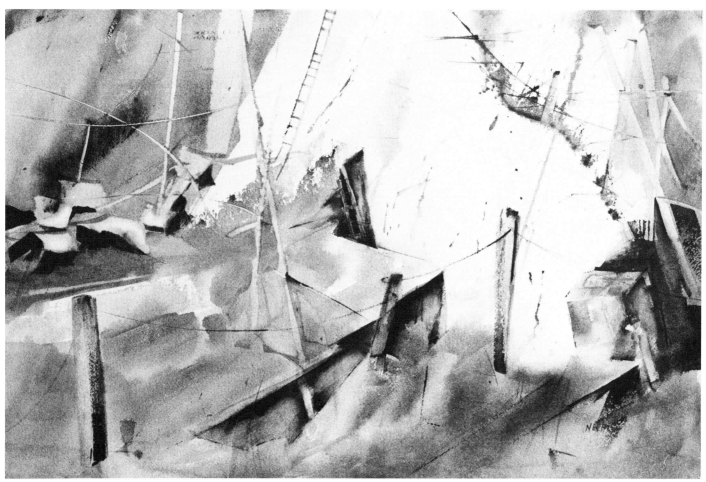

Quarry
15" x 22"
Collection of Roger L. Schultz,
Greenwich, Connecticut.

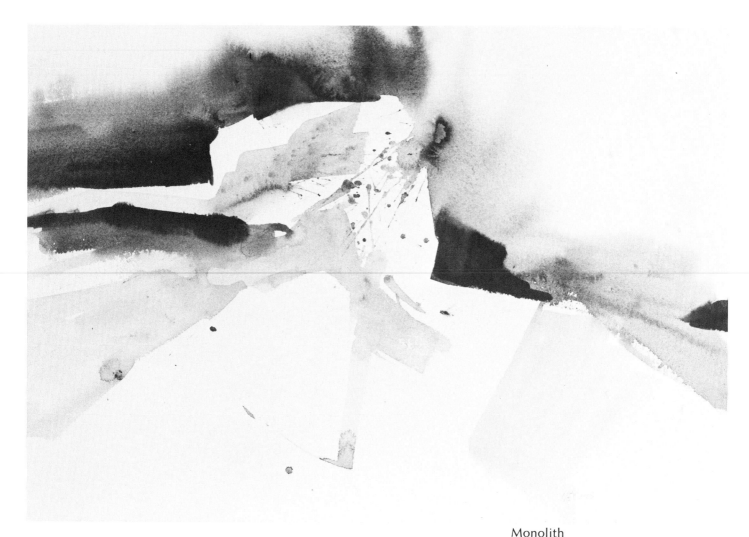

Monolith
15" x22"

The hard crisp edge was attained by wetting the page above the line before painting the upper area. Foreground shapes and the splash were done on dry paper.

Running Wood (detail) Paint dripping through wet and dry areas.

Drips

Drips are used for variety of line. They can be done on wet paper, dry paper, or a combination of both. In "Grasshopper", they were created by lifting the page at the top right corner. A pool of wet paint spilled into the dry area at the lower left and cascaded down the paper in drips. In trying to reproduce this effect, I drew drip lines with clear water, controlling the shapes, then deposited a bead of wet paint at the top of each wet line and allowed gravity to take its course.

"Running Woods" shows the multi-ple effects created by using partially wet paper. The relationship of the wet and dry areas were carefully considered. The wet areas were allowed to soak in to just the right degree of wetness. With the paper held so that the paint would run, drips were dropped into the uppermost wet section. The paint ballooned outward in its downward course until it hit the dry area. Then it formed into a thin line and proceeded down until it ran into the next wet area, where it again

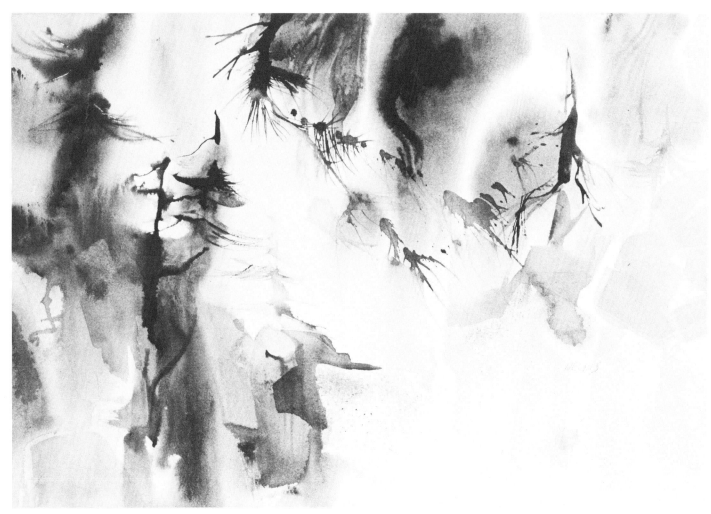

Pine Mountain
15" x 22"

Each soft background shape is separated by a soft white area so that the shapes are emphasized and echo the glazed, spattered shapes which were put in later.

spread out. See detail on page 30.

The drip in "Sapling" which created the tree itself was caused by finding a drip of paint about to run, and using the back of my fingernail to drag it down in the shape of a tree, drawing as I went with my nail.

My next procedure is somewhere between a drip and spatter, a splash! A #6 round brush loaded with wet paint vigorously flicked towards the paper created widely diverse effects in "Quarry", "Monolith" and "Pine Mountain" "Quarry" was painted in a boat yard, but the first stroke, a splash on the dry paper, reminded me of the texture of a rock wall. In "Monolith" the splash was used to texture the center of interest, and in "Pine Mountain" the splash emphasizes the oblique patterns of the painting. Here it is further refined than in the other paintings, suggesting actual branches rather than just texture. A knife was used to drag excess paint from the splash into lines suggesting boughs.

Sponges

Another accidental discovery came about because there was a lack of plain sponges at the local market. I frequently use them for wiping away paint and isolating areas from wet painted surfaces. My first wipe out with the substitute sponge, a Dupont, resulted in fine lines being dragged across the page. These were caused by the cut edge of a square pattern on the back of the sponge. At this point I began to experiment further. I dipped that side of the sponge in the paint in the center of my palette and printed it first on wet paper, then on dry. I tried color over color, and wet over dry, obtaining interesting brick textures. Marvelous effects of carefully painted bricks can be achieved — the kind of rendering project I would never have the patience to begin. My short cut can also be used as a textured passage in an abstract painting. Color variations and alternation between printing on wet and dry paper help to prevent the results from becoming static.

Sponge print

Sponge wipe

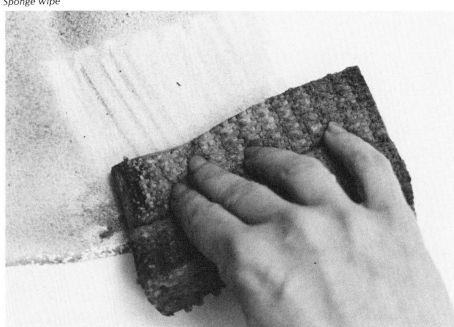

Sponging, wet line drawing, and damp brush lifts.

Shower Lifts

Faucets, showers and garden hoses all have a role to play. A strong stream of water used to wash off paint at varying degrees of wetness creates lovely and sometimes unpredictable effects. Some of the texture in "Curious Yellow" (page 97) and "Leaf Cascade" (page 8) was caused in this way. In "Leaf Cascade" I decided to remove the paint in the leaf area and with a sudden blast of the shower a new texture was created. This method is most fascinating in glaze painting. When a second layer is painted over certain areas, it temporarily rewets and loosens the paint underneath. For this reason, care must be taken to work lightly and swiftly when glazing. If the glaze is rinsed off with force, it will carry with it the underneath paint, leaving unusual soft ragged edges to the previously dried painted edges. The same effect could be gained by painting wet shapes with clear water over unhappy areas and then spraying. Staining colors will remain as tints.

Plastic Scraper

Scraping was once a favorite method of mine. I have tapered off its use in favor of glazing, but I still find it useful on occasion. The scrapers I use are an old Fuller Brush bowl scraper, a Cuisinart scraper, and another from Empire Brush. A plastic credit card could be similarly used. A RUBBER BOWL SCRAPER WILL NOT WORK! nor will this technique work on cheap paper.

I particularly like to scrape out light buildings such as in Village I and II. I generally begin by putting a light wash with value gradations on wet paper. Then the paint is immediately scraped away by applying strong pressure on the tool. The sharp edges create geometric shapes that loosely resemble buildings. The scraped area is fairly dry because the pigment and water have been pushed aside. More pigment is added to carve a shape of trees, hills or other background for the buildings. If this mass is quite dark, a clean edged subject pops out. It also creates a third value. Accents in a stronger dark can add a fourth value. Large trees, telephone poles, masts, pilings, fenceposts and figures can be scraped out this way. It is easier to scrape out a larger shape than needed and cut it down with paint, than to try to control the final shape by scraping. If you plan to scrape your final shape, the paper must be at the exact degree of dampness so the edge will hold. It it is slightly wetter than necessary, a crawly edge will result.

Another use for the scraper is in *printing line*. Dip the edge into a pool of paint and draw with it. A perfect edge will be formed. The risk of depositing too much water on slightly damp paper with a brush stroke is also avoided when the stroke is made with a knife or scraper. A plastic serrated knife or a razor blade scraped on damp paper will produce other interesting texture.

Gulls in Flight
15" x 22"

The most important stroke in this painting is the long angular vertical near the left edge. This scrape out, combined with the dark printed line running perpendicular from its base give an angular dominance to the painting and serve as a frame for the scraped out gulls. I was not aware that my surroundings had influenced my choice of subject matter until later when I recalled that I had painted "Gulls" on Martha's Vineyard.

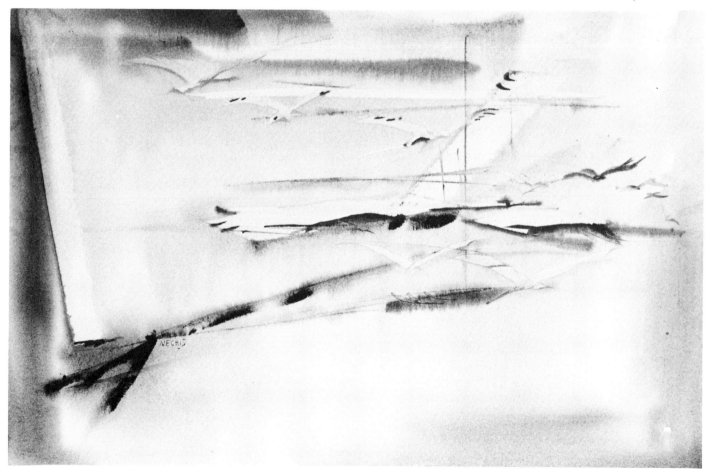

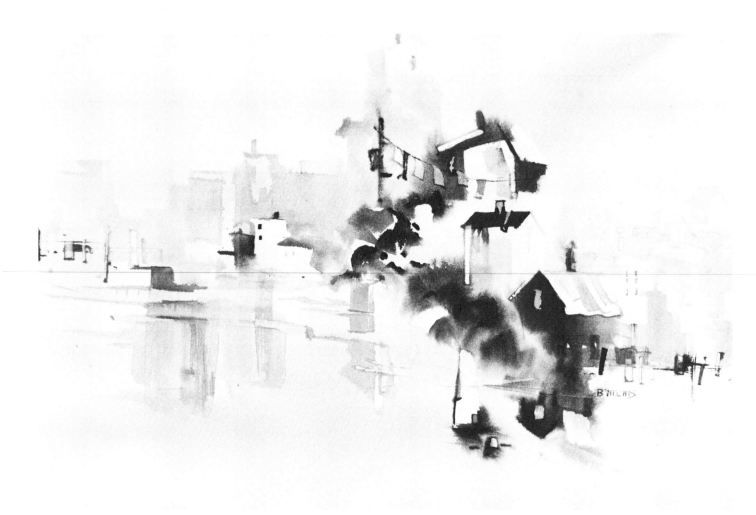

Village I
15" x 22"

The soft pink sky was floated in on wet paper using diluted Cadmium Red. The building shapes were immediately scraped away and darks were placed to emphasize this area. Glaze and scraping finished the painting. Notice the oblique emphasis.

Scraping away paint

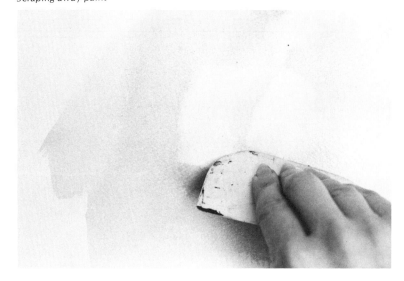

Village II
15" x 22"

Same method as Village I used with horizontal emphasis and foreground left unpainted.

Shapes to create crisp building edge

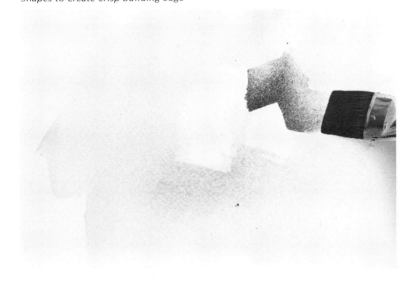

Boat Shapes

A careful rendering was not the intent. My scraper was dipped in a fluid mass of paint and used as a drawing tool to print the curved lines suggesting rowboats.

Partial Wetting

By randomly wetting the paper, it is easy to obtain areas of strong contrast both in value and types of edges. Partial wetting can be done in two stages. If the paper is wet initially with a brush at random intervals and paint flowed on, the dry areas will remain white, or drips can be allowed to divide them.

The areas where the paint touches the dry sections will create hard edges and soft edges will occur on the wet sections. Hard edged shapes such as structures can be painted on the dry portions, with less defined subjects confined to the wet areas.

A second way of random wetting can be done as a second layer or overglaze for a soft underneath painting. In "Rivulets", (page 107) I flowed on soft washes, then thoroughly dried the paper. I then ran water from the faucet on it, tipping the paper to create drips. Finally, a pool of thin colorful paint was dropped on the wet part of the paper. The color traveled through the wet area to form a new abstract shape, brightening the colors underneath. When dry, hard edges were formed where the color remained within the wet portion.

Discriminate wetting is particularly useful when edge control is essential. For example, a subject such as houses can be drawn, then the paper is wet taking care to draw around the houses with water. A sky wash can be introduced appropriately wet and runny, yet contained so that it will not spill into the house area. The structures should be painted when the sky is thoroughly dry. This method can be reversed with the objects painted first, dried, and then the area surrounding them wet and paint flowed on.

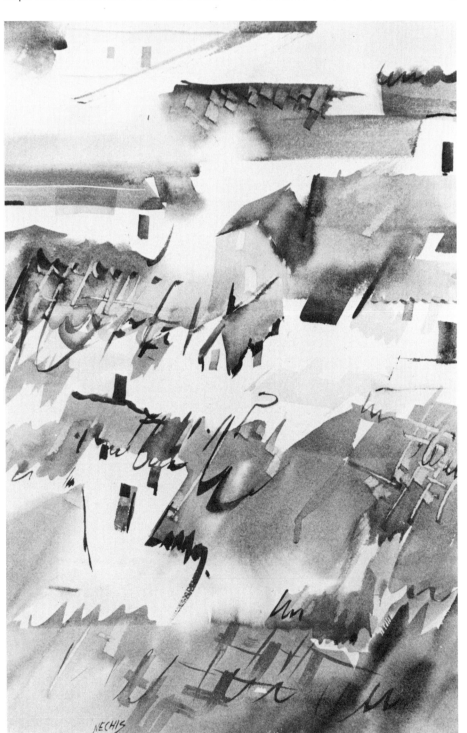

Mediterranean Village
22" x 15"
Private Collection

The paper was partially wet in stripes. You can see how the edges are lost and found according to where the brush hit wet or dry paper. The thin white line on the left upper roof was formed by dipping a flat brush in paint, separating its hairs into two masses with a knife, and dragging the loaded brush over a dry area. Calligraphy added the final texture along with some scraping. Although the building shapes are horizontal, the line and mass carry the viewer's eye obliquely through the painting. Notice the oblique scrape at the top which starts this directional thrust.

Ink Line

Ink is particularly adaptable for use on partially wet paper. Less absorbent papers such as Bristol Board, Morilla, Illustration Board, and any hot press paper are excellent for ink line and wash. Ink can be lovely and simple to use. I often combine wax resist, a tint of wet paint, and ink on partially wet, smooth paper. A plastic drinking straw cut at an angle makes a fine quill. The quill is drawn across the paper creating interesting patterns as it spills ink into the wet color. Unfortunately, ink can be a crutch. Like salt, it looks great but not always very personal as it can react in a similar way for all users. Drawing with ink instead of allowing it to flow randomly on wet paper, introduces the personality of the artist.

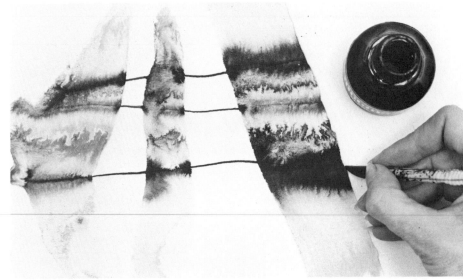

Ink on wet and dry paper

Ink Drawing
12" x 16"

The trees were drawn with a reed found on the ground and dipped in India Ink. At this point I spilled my soda on the paper and drew into it with my reed for the textured areas. Then, I completed the linework at the bottom.

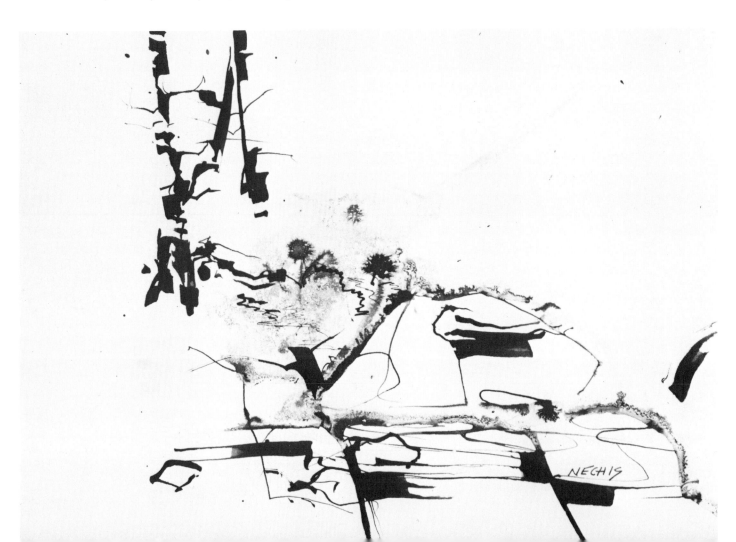

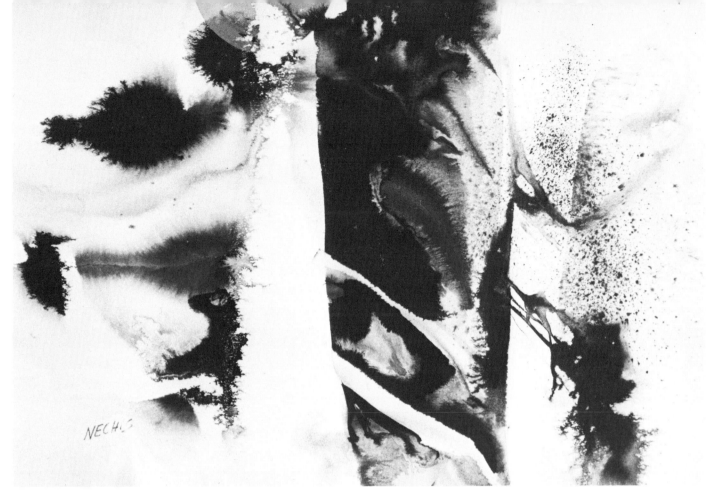

Tree Forms
12″ x 16″

This is a more complex ink painting. The paper was partially wet with some straight edges for contrast to the flowing ink. Spatter was added and an orange sun glazed in at the top when dry, to echo the soft yellows and oranges under the spatter.

Landscape Forms
5″ x 14″

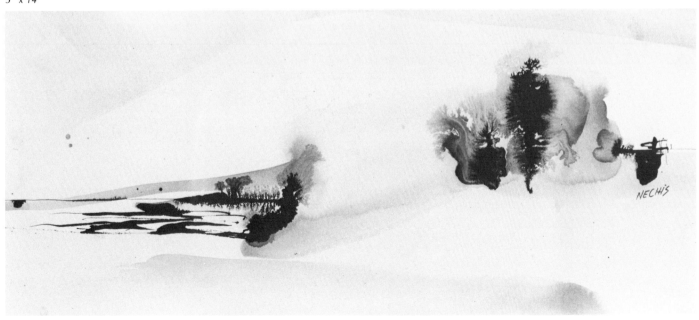

Chapter 3
Development and Design

Attitudes Especially for Beginners

Many of the techniques in this book are devoted to the experienced painter. One must be comfortable with handling paint, understanding the qualities of various degrees of wet paper, and know how to mix color, before using glaze techniques. It is also important to know how to compose a painting in order to be able to analyze its strengths and weaknesses. Basic design must be mastered before concentration on content and personal expression can be total. However, there are attitudes and approaches which the beginner should develop if his goal extends beyond reproducing a pleasing clipping or framing all efforts.

I have never painted a picture that has completely satisfied me. There is always something that should have been done differently. Paul Klee said an artist knows a great deal but he only knows it afterwards. I am often amused and somewhat appalled when a student deliberately tries to copy a painting of mine, errors and all, assuming mine must be perfect, until I point out its flaws.

It isn't easy to be a good student. It requires great perseverence, patience, and hard work. It also requires some faith in your own ability and intelligence. A good way to get the most from a teacher, workshop or book is to start out being receptive. Try the methods presented even if you don't agree with them. Give yourself enough time to gain some technical facility before judging whether the method is right for you. It is a waste of time to go to a class, do your own thing, and not make use of what is being taught. It is just as bad to continually copy the

lesson verbatim. The best way to use any reference is to alter the variables. If a method is used, repeat it with another subject. If a subject is presented, rearrange it in a new design. Alter the colors, substitute warm for cool and vice versa. Try a subject slowly, then repeat it rapidly. Stand up while you work for maximum freedom of movement. Energy must flow from you to your paper.

A common misunderstanding about painting is that the artist must be inspired. Inspiration is not the determining factor at all. What does being in the mood to paint have to do with it? The development of an artist is a gradual process evolving from the daily fact of going into the studio and working. There are no short cuts. One never knows when an "inspired" painting will occur, but the more concentrated hard work is put in, the more likely the successes will be. A studio session is usually draining, exhausting, and occasionally exhilarating. If it is relaxing, something is probably wrong; you are not thinking hard enough. Thoughts race through my head as I paint. Shapes! Value! Color! The more the experience, the more there is to think about. Without thought the process and the result will be empty.

I remember one class where we worked from black and white photos, applying our own color. It was challenging at first. Finally I could reproduce the subject creditably without the need of a class, and remember wondering if this was all there was to watercolor. Without a new challenge I had no desire to continue. Fortunately, I found new

challenges in wet paint and design.

Students often feel that they must copy a scene, photo or other work because they are not creative. This may be an excuse to avoid working in more difficult, uncharted territories. Creativity is often a by-product of hard work and flexibility in approaching new ideas. It isn't necessary to find the perfect landscape to copy. Once basic understanding of a subject is attained, it is vital to consider the arrangement of its components in the composition. A subject can be moved to the left or right, up or down, details rearranged for one's own creation. It doesn't matter where it is placed as long as the pattern, space division, and other design objectives are met. The more technique is mastered, the greater the design options.

After the basics are mastered, it is important to develop self-criticism. Criticism should focus on a workable solution rather than on the problem. You must learn to trust your own judgment. If a teacher suggests changing an area, do so because you agree or understand the reason. Only change your work to please someone else if you feel right about the change. Mary Cassatt believed that acceptance on someone else's terms is worse than rejection.

It is exceedingly difficult to judge new work accurately. If a painting is a departure from your usual style, it is easy to admire its uniqueness. I have often liked a new painting but could not appraise it realistically until it was matted, framed, and standing amidst other work. Some were discarded as failures, and others were better than I had hoped. Frequently a painting rejected from a series of shows will become a prize winner with a different jury. So be a little stubborn if you really believe in a painting. Make use of other criticism, but don't avoid the responsibility of developing and using your own judgment.

Design Analysis

Rather than list a set of rules to follow, I will first raise some questions. Designing should be a growing, thinking process. It should enhance rather than stifle creativity, be a guide rather than a map. It can be dynamic and obvious, or subtle, but it must be there. Some students come to me to loosen up and are surprised to find how little I rely on flung paint and how much on structure. Simplicity can be overdone (or should I say underdone) if it is confused with splats on paper, but when form, grace and space are considered it can be more complete and satisfying than the most complex compositions. A painting without structure is only a surface with paint on it. John Marin said of building pictures: "...without structure (in the mind's eye) there can be no real creation." Milton Avery would "...seize one sharp instant in nature, imprison it by means of ordered shapes and space relationships to convey the ecstacy of the moment. To this end I eliminate and simplify, leaving apparently nothing but color and pattern. But with these I attempt to build an organic whole."

Designing can be done before a painting is started, or it can be part of the painting process. Both approaches are used by the artists in Chapters 5 and 6. The best approach is the one that works for you. One of the reasons that I never thoroughly plan a painting is that I fear boredom more than I fear failure. I have torn up well designed paintings that were ordinary to me, too similar in value plan to others I had done. I have developed a formula or vocabulary of strokes and shapes I sometimes recall which have worked in one painting and might work in another. More often, just before using one of these familiar patterns, I have turned the paper upside down or sidewards to see if I could stretch myself into a new solution and thus expand my vocabulary.

Logic is especially important in landscape painting, which comprises the bulk of my work. However, I both seek and discard it. First I look for a logical conclusion to a painting. If the main part of the subject resembles a stream, what will go with it? Snow or grassy banks might work. But as I put in a wash to suggest this natural form, I watch the direction of the brush and extend it to create both an interesting shape and area so that its concept becomes more important than its reality. Sometimes, an area which needs extending may lead me to skip a space and repeat it further along. For instance, a mountain ducking behind a mist and reappearing on the other side. This tends to make areas advance and recede, disregarding nature. Often I will find a painting of mine quite realistic while others will find it abstract. The ingredients add up to landscape, but when separated by my view of them, they may take some imagination to understand.

There are a number of design rules which can act as a checklist in problem solving. However, after they are absorbed, natural instincts should take over. A common rule is that unequal space division lends itself to interesting design patterns, with the greater the difference between the large piece and the smaller, the more interesting the design. I have no quar-

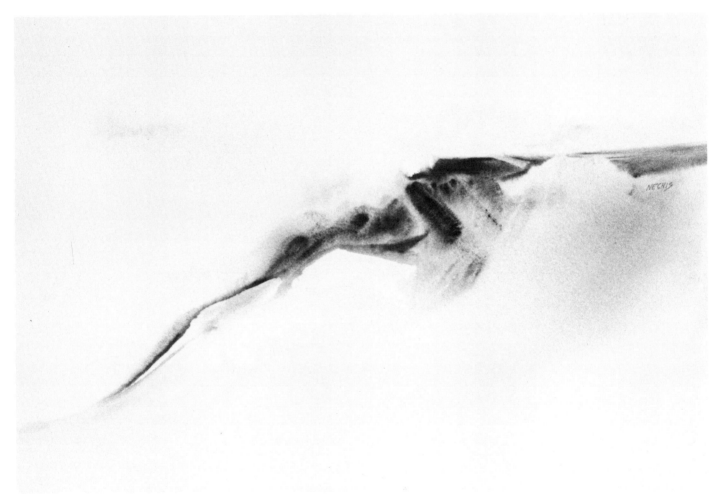

Wave
22" x 30"

This was a brief full sheet painted in Maine as a break between a number of complicated lengthy struggling successes and failures. It is framed without a mat to further emphasize its simplicity. Originally I planned to create a meadow of flowers. On my very wet surface I placed an area of yellow spots followed by burnt sienna and orange ones to suggest flowers in the upper right section. Immediately I changed my mind and tipped the board to let the painted marks flow together. I then defined the shape further by adding the dark and scraping the lower left portion of it to drag the paint and create textural and value changes. This painting could also represent flight.

rel with this premise, but if it were rigidly followed, paintings would tend to become repetitious. It is the differences and oddities which sometimes make memorable paintings.

Many rules seem logical until an antithetical rule is mentioned. Distant water appears paler than near water because it reflects the low sky, while closer water reflects the brighter high sky overhead. But isn't shallow water paler than deep water? These are two opposite concepts and both work. Another common rule stresses the need for a center of interest. Overall pattern can work equally well. There is a danger in embracing any rule without question. A recurring problem for students is the use of contrasting values. I constantly evaluate and criticize work based on readable value shapes of light, mid-tone and dark. However, if this rule were a constant, where would subtle, exquisitely close-valued paintings fit in? Values in many handsome works are sometimes too close to be easily distinguished in black and white reproductions. Variety may be emphasized in one rule and repetition in another.

I raise these questions so that the rules can be used as a guide when needed. If a painting creates an emotional response, that is your aim. If something disturbs such a response, corrections may be in order.

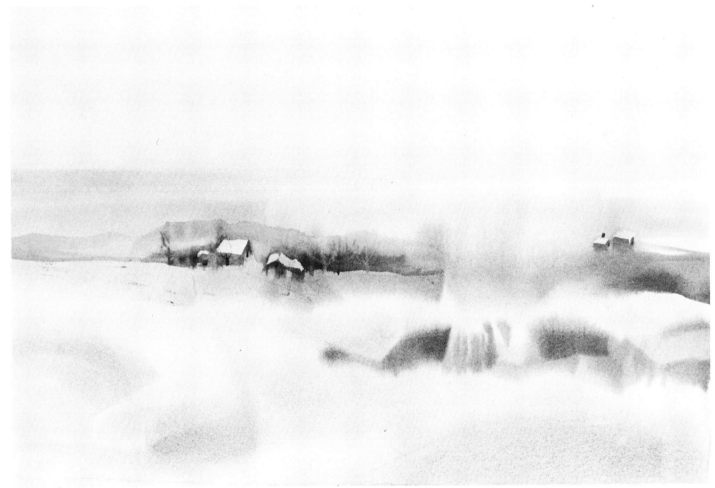

Misty
15" x 22"
Collection of Louise R. Ross,
Cincinnati, Ohio.

The painting began with one idea and changed en route. The bottom washes were originally meant to be the sky. The soft swirls here were caused by sponging. As the next layer of bushes was put in, I felt as though I was repeating a familiar subject, safe, but unoriginal. At this point the paper was turned upside down and finished. The soft foreground, although orig- inally meant to be sky, gives an unusual misty feeling. The houses were "popped out" by glazing the mountain around them after the first layer of paint had dried.

Design Checklist

Color

Is there a predominant color or at least a warm or cool emphasis?
Is there too much sameness of color? Not enough color change or interest?
Do the colors fight? Would neutral grays set off the colors better than complements?
Are the colors interesting or cliche's?

Value

Are the values easily read?
Can shapes be distinguished because they vary in value from adjoining shapes?
Are the light and dark value patterns pleasing? Do they allow or encourage you to look at the important parts of the painting and move through it logically?
Are they too strong (overpowering the subject or subtleties) or too weak?
Are there too many or too few? (three may be uninteresting and seven, confusing).

Shape

Is there a predominant pattern of shapes? Curvilinear, Angular, Straight?
Is there a dominance of horizontals, verticals, or obliques?
Do the shapes work well with the shape of paper being used?
Are the shapes simple and straightforward, with interest within?

Subject

Is it interesting or worth painting?
Does the viewer know where to look?
Does the strongest point of interest have enough contrast in value and color? Is it dramatically placed?

Space

Are there large areas and smaller ones, rest areas and areas of detail and excitement?
Is the subject scaled correctly for the paper size?

Color Balance

It once was popular to teach balance by asking a student to repeat his colors. A loaded brush of one color might be dabbed down in three diverse areas of the picture space. The opposite method is to utilize color as focus. A successful painting can sometimes be weakened by uncritical repetition of color and strengthened by a single dominant note. I am not advocating using isolated color, but it often adds vibrance to a painting, especially if the color is unexpected. Another version of the color may be repeated in other areas of the picture to soften the isolation when needed. Both ways of working may be effective, but they should be used following thought rather than habit. Repeat a color if you need to but only after thinking about it. Instinct is to be trusted but not confused with habit.

Color Choice

While watching a demonstration, a student leaned over and asked me "Which blue do you use for sky?" I was not being facetious in answering, I rarely use blue for sky. As a beginning painter I used traditional colors for a long time. Sky was blue, grass green, and rocks gray. Then I began to be bored by the sameness of my colors and deliberately avoided the old clichés. For a long period I concentrated on the warm colors which I found more difficult to use. It is easy to get a good dark with prussian blue, add varying amounts of water and have a clean mid-tone or light, but with yellow one must be more inventive. I happened to flip through my painting bin in which the paintings were stacked somewhat chronologically. The older paintings were mostly cool colors, with an occasional warm one thrown in, and the later paintings mostly warm. At this point my boredom was over and I went back to enjoying blue again. I also began to experiment with a broader color palette, and the use of more varied colors within a single painting. Often it was a failure, but again, the good ones were worth the struggle — so much more challenging than the limited palette formula which works with boring regularity.

A favorite color exercise occurred accidentally. I was preparing Christmas Cards and decided to combine the task with a better understanding of glaze technique. A number of sheets of D'Arches paper were cut into appropriate sizes and laid on my painting tables in three long rows. I roughly planned a white shape of sailboats, and proceeded to glaze a pattern around them using Yellow Ochre on one third of them, Cerulean Blue on a third and Indian Red on a third. Then the procedure was reversed for the second and third layers of color, each color at some point in the painting overlapping the white and each of the other colors. By the time the cards were finished, I was becoming experienced at creating shapes through layering. All had their merits and it mattered little as to the sequence of washes.

After these experiments I discarded many rules about glazing, no longer caring whether transparent or opaque paint was underneath or on top. Problems occur when too many layers of paint are applied and not enough transparent areas are left to set off adjacent layered areas. All opaques look transparent when thinned enough.

There are times when an artist may fall into a particular pattern or color habit. A series may ensue with a similar color theme throughout. However, at a certain point exasperation is likely to occur due to the repetition and the artist resolves to eliminate a particular color from his work. A peculiar event may occur. In deliberately removing a color from his palette, the artist may still feel the need for it and unconsciously create the color he is trying to avoid. I went through a lengthy period of dependence on Alizarin Brown Madder and finally banished it from my palette. But each time I chose a red or brown, I felt the need of the other to tone it. As a result my paintings looked like I still used Alizarin Brown Madder. My soul was unwilling to give it up. Often we will create mixtures which compensate for deliberately excluded color, just as artists with different palettes can turn out paintings of similar colors. I have a student who works with just six colors. He can consistently match my palette but it takes a little extra time — time I am unwilling to spare. He takes pleasure in the challenge of mixing while I enjoy having a wide range of varied color.

I rarely attempt to match an exact color in nature. Since I have no set idea, I can't come up with the wrong color. Instead, whatever color chosen first will work if complemented well.

Designing with White Space

Don't be afraid to leave large expanses of white paper. Some artists feel that a painting is finished when all areas are covered. Many of my pictures would have been overworked had I not realized at an early stage of the painting that it could stand as is.

I consider white space in a painting as I do any other shape. If an entire foreground is left white, does this diminish the painting more than if the shape had been painted in a midtone? I am never in a hurry to cover up my white shapes. They breathe life and are excellent foils for vivid color.

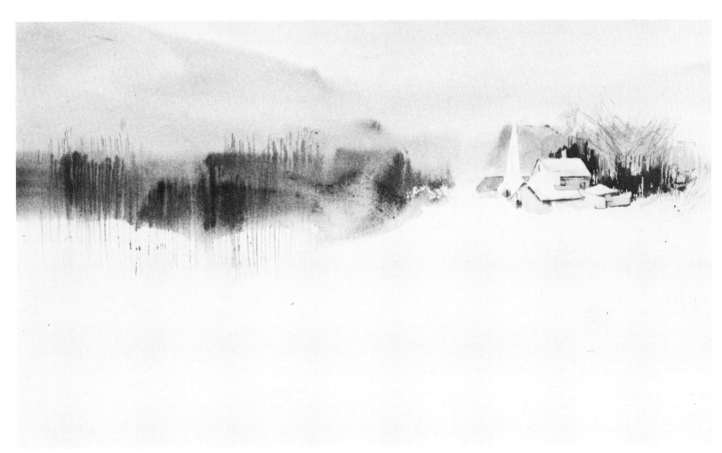

Winter Space
15" x 22"

The decision to leave the foreground pure white paper came after seeing it matted. Rooftops were taped and washed out to bring the white into the painted area. The tree shapes at the left were dragged in with a knife.

Navy Edge
15" x 22"

How close can you come to keeping paper pure and still create a shape? The dark glazed top section creates both a minute shape and an enormous expanse below it for 'great range in space division. Yet this small dark area has great variety in the shape of its lower curve, its loss into the suggested tree area, its soft value changes and hard linear verticals. The curve is repeated by a long oozle at the lower edge of paint. Is there enough in this painting for you? It was for me so I put it aside and did a second demonstration to fill out the allotted time rather than overdo a successful statement.

Negative Shapes

I haven't the slightest idea why, but I have always been more comfortable with negative than positive shapes. Perhaps this is related to the free use of white space. In any case it often feels natural to me to create a shape by painting around it. One reason is that in my search for innovative solutions, I try to avoid the obvious. Most artists will fill in a foreground while I will glaze around it to create negative rather than positive rock shapes or weeds. My tree demonstrations invariably turn into "Non-Trees" emerging from surrounding forms.

A Quiet Place
15" x 22"

Three oozles and some line produced a finished tree for me. The oozles form a soft, negatively shaped tree trunk within. Each oozle is a deliberately different size and shape, with varied interest within. The branch was printed with my scraper as was the tree texture. Wet line drawing is demonstrated in the upper section. How much simpler can a tree be suggested than this one?

Green Light
In The Forest
15" x 22"
Collection of
Mr. and Mrs. Paul B. Lacy, Jr.,
Fiddletop Farm, Covington, Virginia.

The subject is composed of negative tree shapes, accented by strong dark suggestions of a tree, leaves, and a shape of dark to carve out the midtone leaves. Curves dominate, and angles direct the eye at the strongly contrasted point of interest.

Center of Interest

This particular phrase made me uncomfortable as a student, because it assumed *A Point of Importance*. A painting may have many. I would rather think of a path or flow of movement which is dynamic, rather than a point which is static. However, for identification purposes, this term will be used to denote a particular area in a picture that has more emphasis. A way of selecting this area is to mentally bisect the paper from corner to corner and choose a midpoint between corner and center for developing an interesting place to look.

The following paintings each have a focus at one of these points. In creating a place of emphasis, the design can be established before starting, or it can be created as the painting takes shape. It can be the first area painted, the last, or anywhere in between. Starting places are as follows:

1 Traditional Method — From top to bottom. This is particularly effective in landscape where horizontal movement is stressed. It is logical to paint the sky first, and then suc-

1. Traditional method

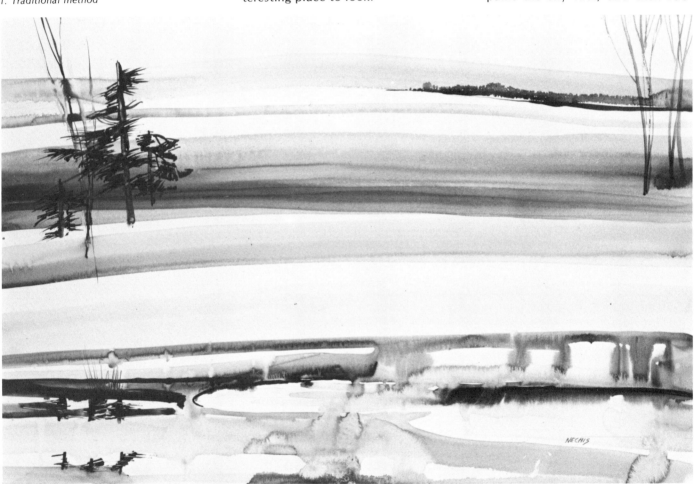

Landscape Levels
22" x 30"

Painted on Bainbridge Illustration Board without prewetting. This is a fine example of starting at the top and working down the page. The strokes of paint set immediately on this paper and overlapping layers can be placed in sequence. The trees were painted in last with extra emphasis at the left. Notice the stripe at the top of the page. This was put in to show that the objective was stripes first, landscape second. There are no mountains or plains, only stripes. Without the details there would be no landscape.

50

ceeding areas down the page. Emphasis can be added later or in sequence.

2 Center Start — If the area of interest is large, or closeup, by starting at the center and choosing a direction to expand, the emphasized area becomes a part of either the upper or lower left or right section. There is little danger of planting the emphasis smack in the middle by carefully expanding from the center towards any corner.

3 Border Start — This is a particularly effective way of making negative shapes become the center of interest. The light area is cut down to the desired shape and then emphasized by adding darks.

4 Center of Interest Start — Can be used in any of the four sections to be emphasized. It is helpful to remain flexible. Many paintings can be started at this point and then the interest shifts as new parts of the painting are developed.

2. Center start

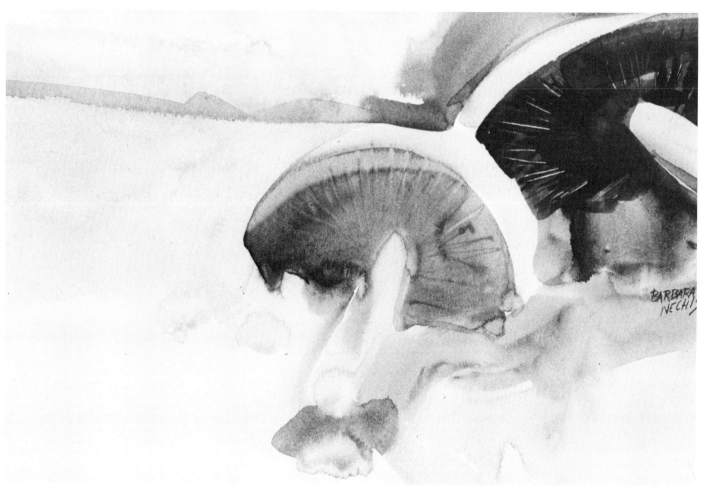

Mushrooms
12" x 16"

This painting is also on Bainbridge Illustration Board. It is an example showing a center start and developed so that the upper right becomes the center of interest. The curves of the mushroom were painted one after the other. No pause was needed. This caused a soft edge, but no running into other areas. Lastly, the washes were placed around the mushrooms and the lines knifed out before drying.

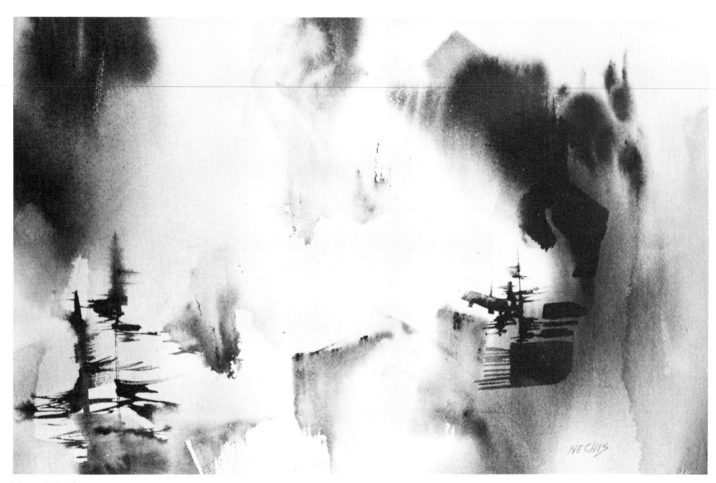

Mountain Space
14" x 21"
Private Collection

Wet paper and flowing paint sug-
gested a theme. The whites were
cautiously cut down in the middle sec-
tion leaving a path to link the darks.
The trees in the lower left were sug-
gested with scraper line, and the lower
right section strengthened for a point
of interest.

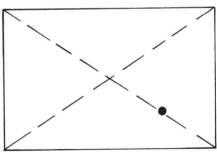

3. Border start

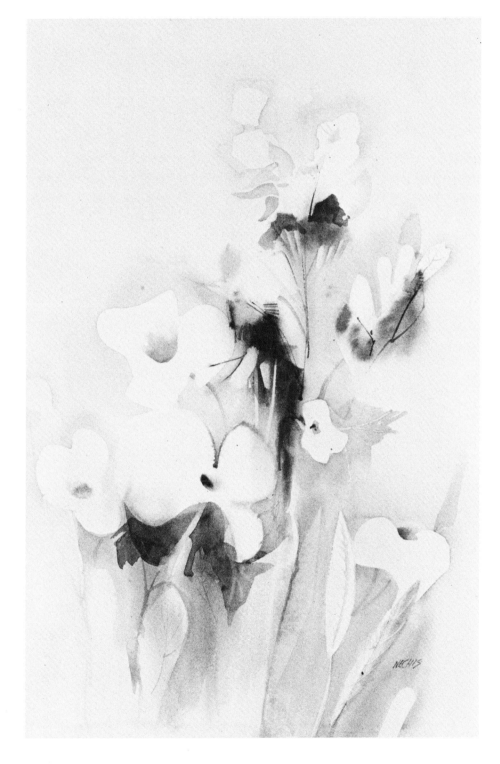

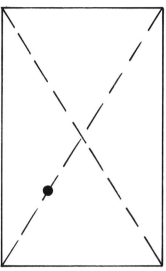

4. Center of interest start

Garden
22″ x 15″

A hint of a soft wash toned the wet paper in a few areas and then the paper was let dry. Then I began glazing around the large flowers at the point of interest, washing away the outside of the glaze so only the white shapes are noticed. Each shape is slightly different in size and outer shape, but the three form one larger simple shape. The glaze was continued around the other flowers and the dark glaze added for emphasis.

Paper Shapes

A sheet of blank paper can cause anxiety for many students. As a beginner, my choice of subject matter was limited by my technical ability. A partial solution was choosing a shape of paper which would assist. A successful series of paintings ensued on long, narrow, horizontal papers. Landscapes can often be enhanced by working this way as a directional dominance is immediately achieved. By using two thirds of the paper for sky, the remaining portion for textural foreground passages, the rudiments of composition were being instilled. The landscapes became more complex as trees and buildings were introduced. Since details require more experienced control limiting these to small areas provided me with more success than if larger or less suggestive paper shapes were chosen.

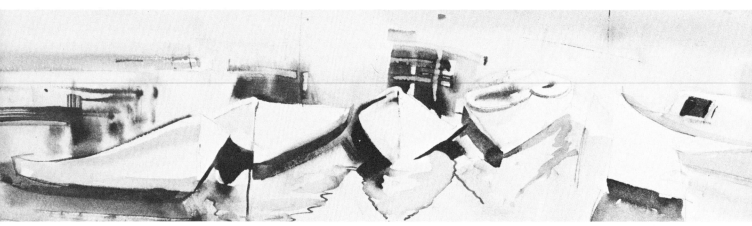

At Anchor
7" x 22"

The boats suggest a long horizontal of continuous white shapes. The area around them was wet and soft washes were added. A few dark accents and scrape marks add finish. The boats were initially drawn with a Pentel pen. Additional line was put in with a brush.

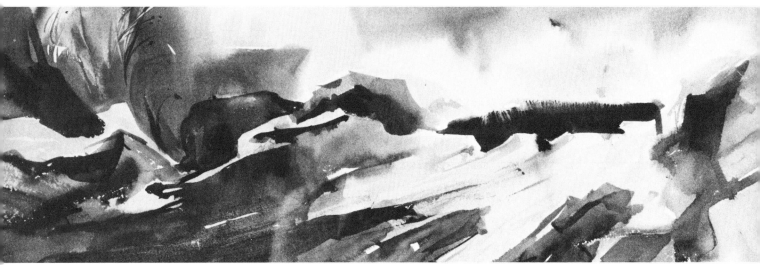

Cape Elizabeth
8" x 22"

An oblique rather than horizontal emphasis makes the paper appear less skinny than it might have. Strong value contrasts lead the eye from foreground to surf, giving depth. Soft sky and water offer a contrast to the hard rock shapes.

Vertical Format

A traditional size for many watercolorists to work in is either a full sheet 22″ x 30″ or half sheet 15″ x 22″. The half sheet is proportionately narrower in width to length, making it more suitable for landscape which emphasizes the horizontal. However, when used vertically, the sheet tends to appear long and skinny. By matting out to the side edges and covering more of the top or bottom with the mat, the problem is somewhat alleviated. To design with this problem in mind is the best solution. An emphasis on oblique shapes will direct attention from side to side, allowing the eye to linger without falling out at the bottom. Painting all the way to the side edges, and having uncomplicated washes at the top can help.

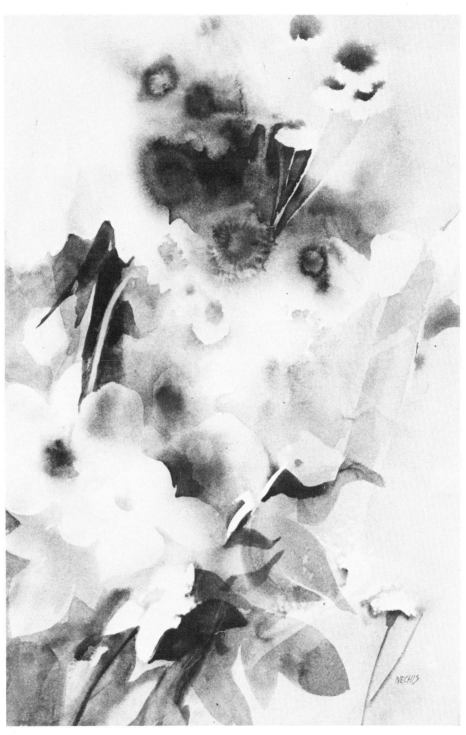

Dogwood Plus
22″ x 15″

This was a complex painting done in several stages. The wet darks near the top and the smaller ones further down mark the first step. The white flowers at the left edge were glazed around using the value of the leaf underneath. That value became a leaf when another shade darker was glazed around it. The leaves at the bottom right were positively glazed. Notice the oblique directions which move the viewers eye from side to side, softening the long thin shape of the paper.

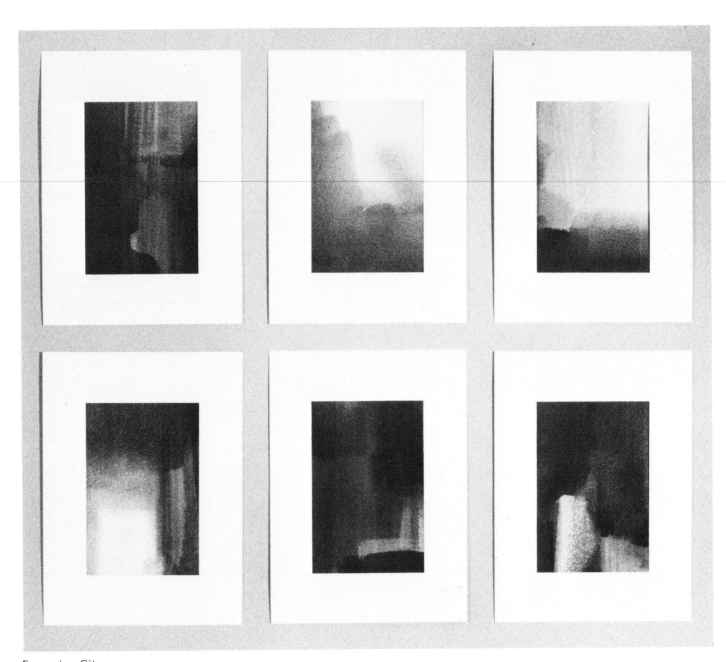

Emerging City
22″ x 24″
see text

Progression

Series work can be an excellent solution for creating large paintings without the problems of working on a single expanse. However, they must be well planned and the designing process must be carefully thought out. A series can either be a progression of something happening, a process such as a subject moving in space, changing in shape, becoming larger or smaller, emerging or disappearing. Or, it can be a diptych, triptych or more with interlocking parts to create a total landscape or abstract. In both types the parts can be framed separately, or mounted in a single mat with separate windows.

Decisions must also be made concerning the space between sections. This must be planned before the painting commences. A curved line will appear continuous if matless sections are placed close together with only a thin frame separating them. If larger space between sections occurs either by matting, spacing, or both, the continuous line will not only be broken, but it will lose its original contour unless the space is compensated for. The same problem occurs with shapes. Other design difficulties can be caused by dissection. A curved emphasis can be flattened by a frame cutting through.

I have explained what a progression is. Now I will explain what it is not. It is not a painting cut into parts. If the parts cannot stand alone, not only is the progression weakened, but it is pointless. Separation of the parts emphasizes weak areas. The work must stand as a whole, complete design, and the individual parts must work as complete, separate entities as well as parts of the whole.

"Emerging City" is a six part painting. Additional sections were painted and the final shapes were chosen with great care. The selection process was excruciating and I was both drained and exhilarated at the end of that studio session.

Detail of "Blizzard"

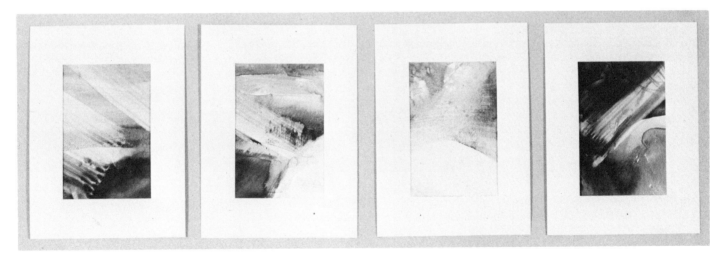

Blizzard
12" x 36"

This progression was painted on gessoed paper. Paint, ink and sponge marks all contribute to the textures.

Chapter 4. Glazing

There are two opposing methods of creating watercolor paintings. Both are invaluable. Not all watercolors include both methods. The first is described as the wet-in-wet — paint is applied to a pre-wet surface. The second is called glazing. This is applying paint in a transparent, layered fashion to dry areas and each layer must be completely dry before a subsequent layer can be laid over it. I often begin with the wet method to establish excitement and gradually add glazes to develop a design. Glazing is the easiest way to create new value shapes and to make distinctions between close values.

I love working both ways equally well. Sometimes when I am in the wet stage I long for dry paper to glaze and when I am glazing I wish I were working wet. My solution is to work on several paintings at once. I set aside today's wet starts and work on glazing yesterday's starts. Back and forth I go, for each glazed area rewets a portion of the paper and that too must be dried before proceeding to the next glaze. Working on many paintings at the same time enables me to resist that fatal step of going back too soon, when the paper is still damp. If I am in a hurry, I use a hair drier to speed drying time.

Hard and Soft Edges

It takes some experience to understand the mechanics of a process. What is apparent and immediately visible may be deceiving. An attempt to reproduce a painting technique may fail if the underlying process is not understood. The use of a hard edge is one such case. Hard edges are necessary for forming architectural subjects, or any protruding surface such as rock, wood, tree trunks, or buildings. The edge is often desired for use in water, reflections, or in any passage where differentiation between objects is desired such as still life components, tables, fruit, backgrounds, etc. There are several ways to create hard edges. I find that the most indirect method is the easiest and the result the most satisfactory. This method is the most difficult to detect, yet the easiest to use.

A hard edge can only be formed on dry paper. This means that a pre-wet paper must be thoroughly dried in the area needed to create the edge. The edge may be formed by either positive or negative painting. Positive means

you paint the shape itself and for negative effects you paint around the desired shape. In direct painting for example, a shape will be painted. It must be completely dry before painting the adjoining shape. Some artists skip from one area of the picture to another to allow drying time. In this way isolated parts of the picture are painted at random and areas filled in as drying occurs. To prevent a dry look to the pigment, each of the painted areas can be carefully wet to the drawn edge and then filled with color. The color will be contained in the wet area, a hard edge preserved, and a wet quality attained. Likewise, this quality can be achieved by painting directly on the dry paper and immediately hitting this painted area with drops of another color or value. The first layer of paint acts in the same manner as the initial layer of water. The runny areas in Carl Molno's painting were created this way (page 84).

I prefer to create many of my hard edges by overglazing. Sometimes a wet runny sky will seem bland. By

turning the picture upside down and over-glazing the sky area, shapes can be controlled by a hard edge where the glaze is stopped. An example of this is in "Lejania" on page 97. In "Mirage" on page 98, the illusion of sky is emphasized by the hard edged, small shape in the right upper corner. Such arbitrary shapes create excitement. One flat wash of purple created two separate planes. Additional drops of pigment added variety to the corner area. A beginner, attempting to reproduce this effect might have tried to paint the corner piece first as a separate entity. He would not realize that it was painted over the red sky area and was one of the last areas to be painted rather than one of the first. Mary Blackey's glazes (page 95) illustrate this point well. None of the shapes are separate, but each succeeding hard edged glaze creates new shapes in addition to the shape itself.

Another method of painting a negative shape, is to outline an object and then quickly add water to wash away the outside edge of paint leaving only

(Continued on page 62)

Wild Bouquet
15″ x 22″
Collection of
Mr. and Mrs. Kenneth Bounds,
White Sulphur Springs, West Virginia

Contrasting soft and hard edges are the distinguishing factors in this painting. The paper was wet and the soft upper flower shapes flowed in along with soft washes below. The dark foil behind the flowers was put in while the paper was still wet. The bottom flowers were negatively glazed on dry paper.

Soft edges were created by using lots of pigment and little water on very wet paper. A hard edge was created by a negative glaze over previous wash.

Soft edges were created by using lots of pigment and little water on very wet paper.

Hard edge was created by negative glaze over previous wash.

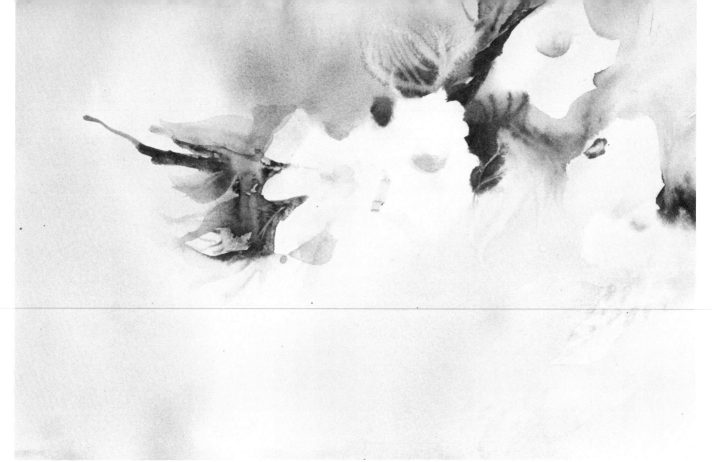

Glazed Flowers A — Incomplete painting.

Glazed Flowers B — Additional negative shapes of flowers and leaves were created by painting an outline of the shape and flooding water to wash away the excess.

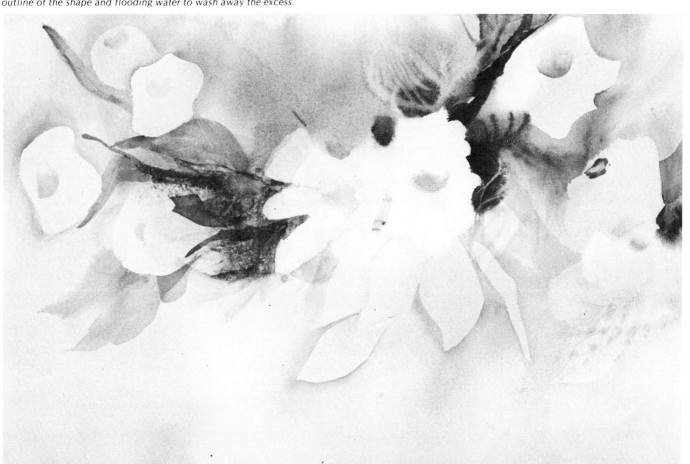

This example was painted with a single wash. When dry, a second wash was placed over the upper section to create a hard edge. Notice the granulation where Permanent Blue and Van Dyke Brown Umber settled.

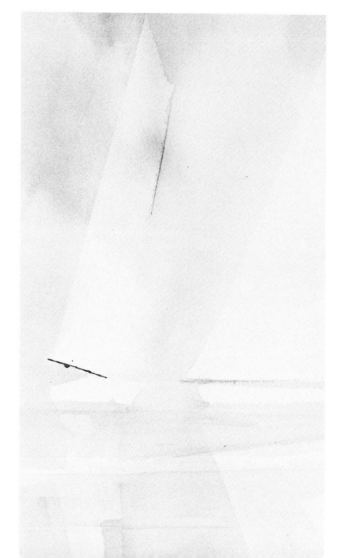

Tape was placed on the dried wash to form a sailboat shape. The paint was scrubbed, blotted, and the tape removed. The foggy feeling was promoted by scrubbing less paint from the paler wash area to lose the front of the boat.

(Continued from page 58)

the part defining the object. "On The Rocks" (page 64) and "Yellow Birds" (page 67) as well as many of my flower paintings employ this method. There will be only a slight value difference between the object and the outside area, but the contrast will be heightened by the edge. Do not confuse the idea of edge of shape with outline. An outline divides areas by line. Edge of shape plays up the value difference even when it is slight.

Some subjects lend themselves to drawing after the initial wash has dried. "Yellow Birds" (page 67) was done this way by disregarding the initial wash and drawing interlocking shapes of birds. Then fairly strong yellow was applied around the edge of the bird at the bottom of the picture and more water added to flow the paint to the edge of paper. Again the paper was thoroughly dried and the process repeated with the second bird. The second object appears slightly in shadow since it was created over the diluted wash which formed the first object. Each succeeding object becomes slightly more shadowed. This method is particularly effective in painting flower petals such as in "White On White" (page 139). The

non-glazed area, or basic wash then becomes the basic shape in this negative type of glazing. Negative glazing creates a light patttern of objects on the paper. Positive glazing does the opposite. The original wash becomes the light background for mid-tone shapes such as in "Sunset Sails" on page 65. In this picture much of the original wash was in yellow with the glaze in purple to both mute and play-up various parts of the painting.

More complicated glaze paintings are those which combine the two techniques so that light and mid-tone shapes interlock. The second layer is always the key to the glaze. Since it is applied to a dry under surface, drying time is much faster than in the original wash and it is important to work out to the edges quickly so hard edges are formed only where wanted. Here too, corrections can be made. This second wash can be immediately flushed off without disturbing the underlayer, if it has not been allowed to set. Details can be created by scraping through the second layer with a dull knife to create line. Or you can again draw with a brush and water. Washouts can also be executed at this point by creating positive or negative stencils.

Stroke one

Outside edge washed away

Stroke two

Stroke three

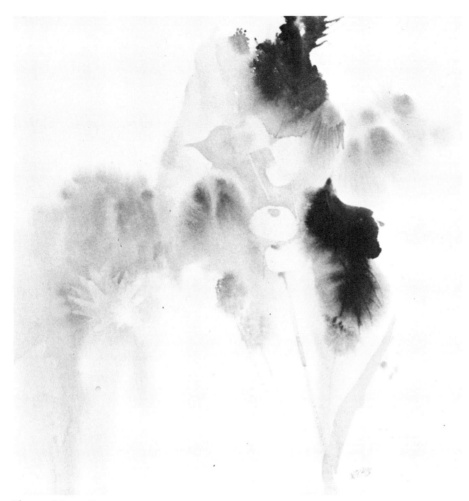

Flower Vignette
15" x 22"

This vignette emphasizes softness. Even the hard edges created by glazing do not feel hard because they are close in value to the shape they have created. Three layers of petals form the flower at the left. Each shape was glazed, washed away, and dried before proceeding to the next layer as shown on the preceding page. This achieves a shadowed look. This method was also used in "On The Rocks" (page 64) and "Yellow Birds" (page 67).

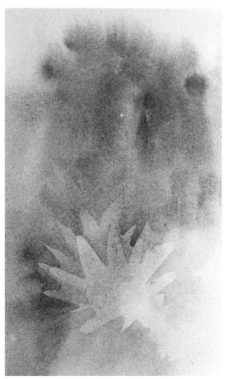

Detail

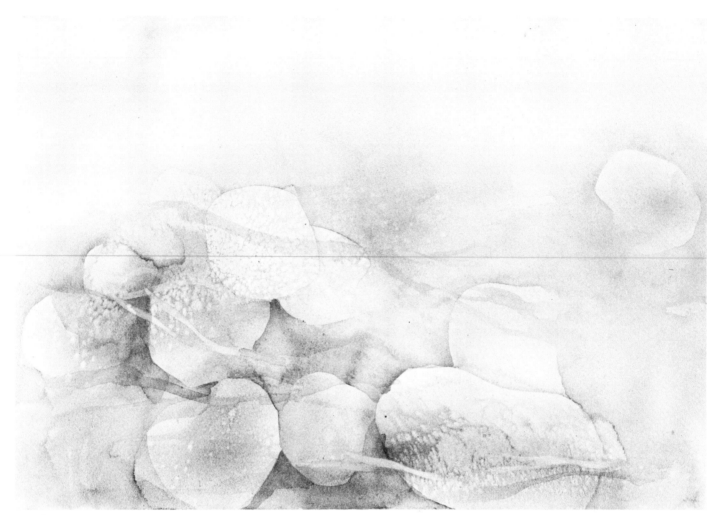

On The Rocks
15" x 22"

Salt produced the textures in the initial wash. When dry, the large foreground rock and the upper middle one were negatively glazed and the excess paint washed away. As each area dried, an adjoining rock was glazed around. The final step included painting curved, pale horizontal lines over the rocks and washing out similarly shaped line by using a stencil of D'Arches paper. This adds to the under water feeling and breaks the monotony of similar shapes.

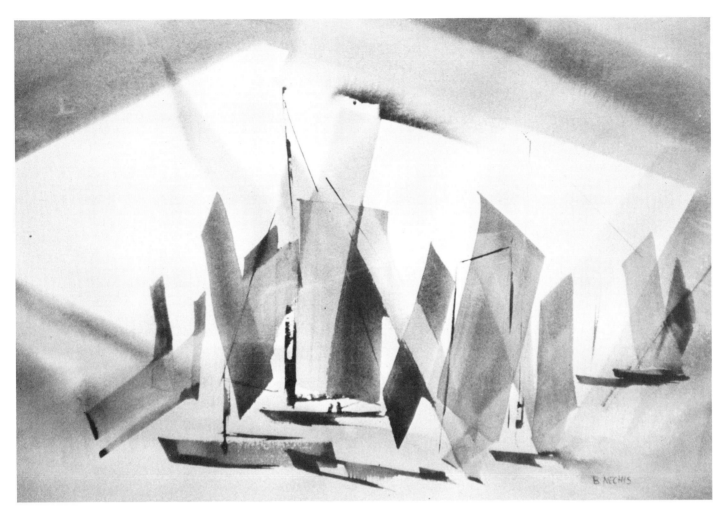

Sunset Sails
15" x 22"

This is an example of positive glazing. The wet paper was painted with tones of yellow. When dry, the curtain effect was glazed over it to gray some of the yellows. Then the sails were painted in and immediately scraped across to add variety to the shapes. The dark lines were printed last.

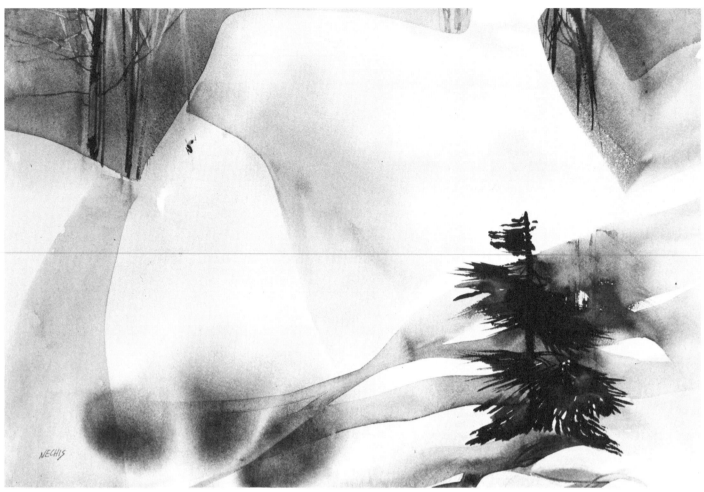

Downhill Racer
15" x 22"
Collection of Dolores Yvonne Ryan,
Kingwood, West Virginia.

This is an example of combined positive and negative glazing. The soft wet underneath wash was deliberately ignored during the subsequent glaze. Glaze patterns stretch the landscape into bizarre shapes. The background areas were glazed to form the top edge of the hill. A second glaze was added in the top right corner for another dimension. A positive glaze was placed to the left of the skier to define the edge of his slope, and a "wash-away" glaze defines the right side of the slope for variety. Foreground shadow glazes and detail were added last.

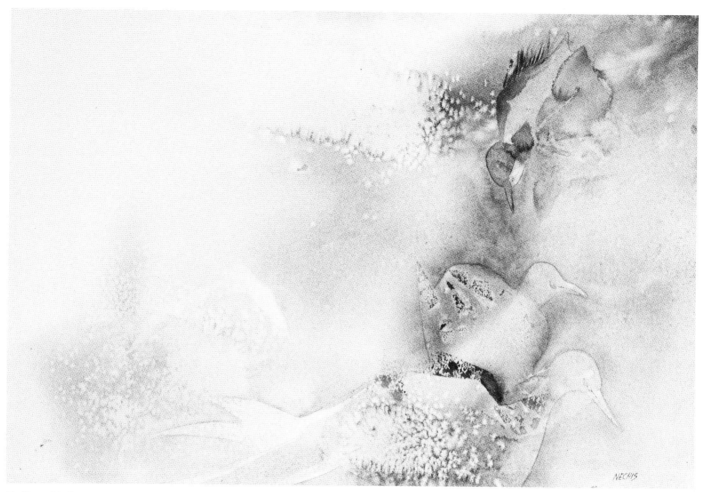

Yellow Birds
15" x 22"
Collection of Ellen and Tim Pyles,
LeRoy, West Virginia

This demonstration used salt, glaze and strong color. Salt was sprinkled on the initial wash to create texture. When dry, the interlocking bird shapes were drawn, disregarding the initial wash. Then strong yellow pigment was applied around the edge of the bird at the bottom of the page and water added to flow the paint away from the bird to the edge of the paper. Again the paper was thoroughly dried and the process repeated with the second bird. The second object appears slightly in shadow since it is created over the diluted wash which formed the first object. Other textures were produced by monoprinting with plastic wrap in the middle and upper bird.

Stencils

A useful and reliable tool for recreating white space is the stencil. I make stencils out of several materials, in both positive and negative shapes. Whatever stencil material you use you'll find a sponge or toothbrush helpful to scrub away unwanted paint.

Masking Tape

Strips of masking tape are placed on the paper, in a shape large enough to cover the area needing change. The desired shape can be drawn on the tape, for example a leaf or boat. A razor blade or mat knife should be used to etch the pencil line, and then the excess tape of either the positive or negative shape, can be removed. There are four options. The silhouetted area can either be washed out or painted, depending on whether an area lighter or darker than the original is desired. Conversely, the tape surrounding the area can be removed so that the drawn shape remains covered. Then the area surrounding the tape can be either washed away or painted to contrast with the covered area. The area is then blotted if it has been washed out, or allowed to dry if it is painted in, and the tape removed.

Fog at Anchor (Detail)
22" x 24"
Collection of
Mr. and Mrs. Americo Ventura
Danbury, Connecticut.
Courtesy Voltaire's Gallery,
New Milford, Connecticut

Three methods of creating a leaf

Washing out stenciled area
Glazing around an area
Scraping away wet paint and carving a new shape

Tape stencil on white paper.
A-E see next page.

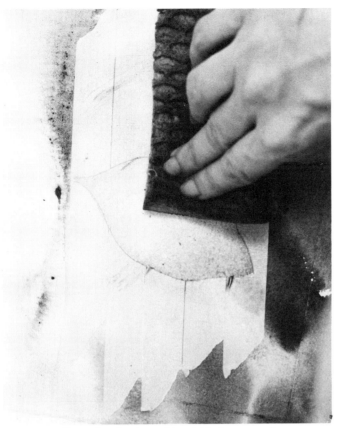

A Tape stencil on painted surface with paint being sponged away.

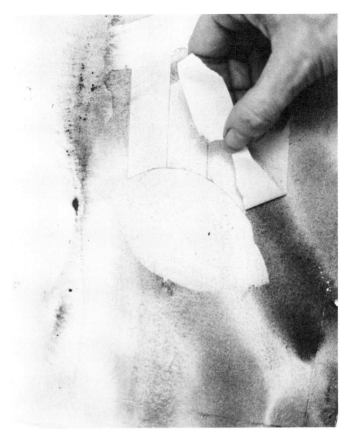

B Removing tape

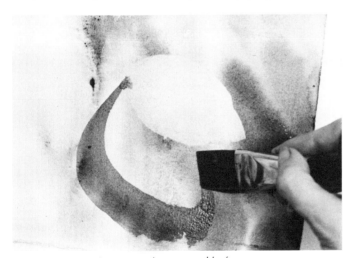

C Painting around an area to form second leaf.

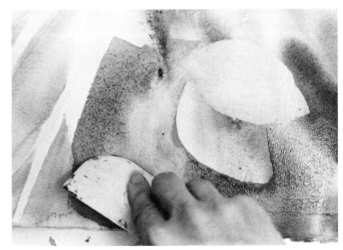

D Scraping away paint to lighten area.

Advantages — Edges are clean since tape adheres well. If the paint is well set, toothbrush scrubbing to agitate the area will not disturb the covered areas. (Brush away from the taped edge and blot excess water frequently.)

Disadvantages — The method is slow if overlapping shapes are desired. The paper must be dried after each shape is made and the taping process repeated. Tape sometimes leaves a mark when removed.

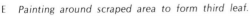

E Painting around scraped area to form third leaf.

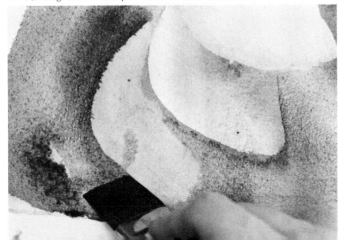

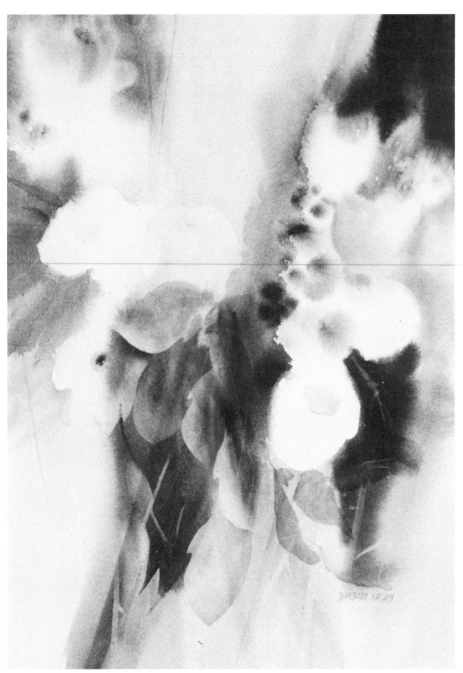

Bouquet
30" x 22"

Paper Stencil

Shapes are cut from scrap D'Arches paper and placed on the dry painting. A damp sponge is used to wipe paint from either the positive or negative shape used.

Advantages — Smooth, less obvious hard edges are achieved. See the leaves in "Bouquet" above. Versatility in changing patterns, moving stencils, and in cutting shapes.

Disadvantages — Water can leak under stencil if care is not taken.

In "Bouquet", the leaves were washed out by cutting a stencil of D'Arches paper, laying it lightly over an unhappy area and scrubbing lightly away from the stencil edge with a sponge and toothbrush. Each area was blotted and allowed to dry thoroughly before placing the stencil on an overlapping

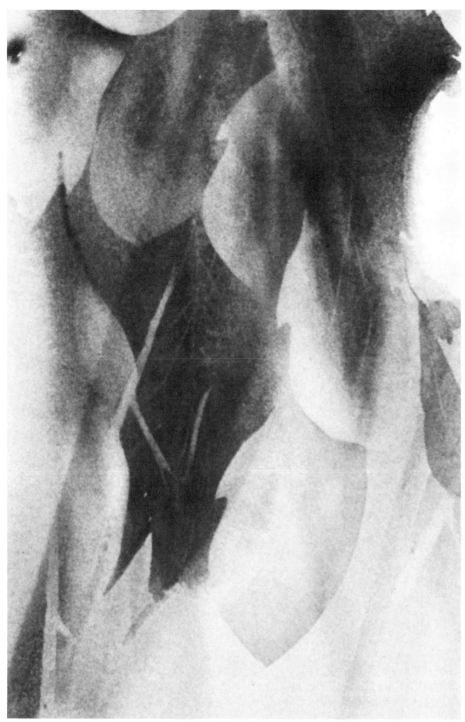

"Bouquet" (detail of leaves stencil washout).

area and repeating the procedure. Since areas are covered with part of the stencil, each time it is moved and used, you will be estimating rather than calculating the result. To eliminate the guess work, a drawing could be made on the paper, traced, and stencils created to the specifications of the shapes. Before washing out the leaf shapes in "Bouquet" a large, dark blue leaf covered the entire area where the leaf cascade is formed. I had used some garrish greens which would not wash out, and my attempt to cover them compounded the problem. The stencil solution both changed the initial shape of the area and introduced pleasing value changes.

An interplay of layers, developed through glazing and washout methods, creates a complex filmy look which is impossible to achieve any other way. The building process is quite simple if done layer by layer. I often look at my paintings and cannot remember which layer came first, and which areas were washed out, scraped out, or glazed around.

It is the result that counts, not the method. However, glaze techniques can be of great help in providing the control needed to make a successful personal statement with watercolor.

Chapter 5.
Developing Personal Style

We are all born with a potential for individual expression. Two strong influences are our own innate personalities and the outside forces with which we come in contact. Often a student is impatient to develop a recognizable style and forces himself into a mold, seizing upon gimmicks or easy methods prematurely. Conversely one may be unhappy about a strong teaching influence and may either be fighting it too much or accepting it too readily. It is important to develop a relaxed attitude about this problem, and keep yourself open for new experiences. Of course, in the initial period the student should concentrate on technique until it becomes second nature. There is always a fine balance between a teacher's obligation to encourage individual traits in his students, and the student's obligation to pursue self awareness. To illustrate this point, I had a class select a newspaper clipping to use as the basis for a painting idea. After an hour of painting, we placed all of the work side by side and tried to match each with the artist. There were twelve paintings of the same subject, yet it was easy to identify the artist. The personal style could not be repressed.

My style has changed considerably over the last ten years, but there is a definite link between my earlier and recent work. I delight in tackling new ideas so that my paintings range from realism to abstract, from simple to complex. My creative growth began with self doubts about my own ability; went through a period of technical learning, copying from nature, using reference material for ideas, and finally letting the paint lead me as far as it

could. I try to stretch myself to bring about logical conclusions. The combination of using the natural tendency of watercolor to flow, and forcing it to fit into my design concepts is what created my personal style.

I capitalize on a poor memory for detail and a vivid recall of impressions. A common artistic experience is being reawakened by nature each year. I have an early memory of driving home from an art class and feeling I were seeing trees for the first time. The fall foliage on the ride home hit me with startling impact. I noticed new color and detail vividly and yet when I tried to paint from my memory, the details had faded.

Each summer I return to Maine and my senses are visually assaulted by details forgotten from the year before; how the water laps at the rocks, the color of moss under water, and the color later when the tide goes out. But again my memory fades when I begin to paint. Part of the reason is that *I let it*. "Spindrift" (page 101) was painted from my balcony overlooking the sea and rocks at Linekin Bay. I tried hard to look at the rocks below as I painted, and to catch the colors under the tide. But, before I knew it I was caught up in the flow of paint. I expressed the air, spray and rocks, by following the movement of paint and then directing it. The scene below slipped from my mind and I became totally involved in the scene I was creating.

I always feel, now I have created something new that I have not seen before, and I can still paint the original concept at another time. Somehow the new continues to develop and I never get around to the subject I was

originally drawn to. I never have a vision of what my finished painting will be. The development process determines the final creation. I am encouraged by Degas' belief that "...a painting is first a product of the artist's imagination, it ought never be a copy...It is much better to draw what remains in the memory."

Although a major commitment to studio painting is the only method I know of for a student to develop into an artist, the growth process can be a lonely one. Painting with others of similar ability can be a fine stimulus, however the danger of sharing studio space involves or promotes over influence and a blending of styles can occur. I limit my working with friends to a stimulating few days a year and often share thoughts with others whom I admire but whose style does not personally blend with my way or desire to work.

At one time I was terribly impressed by the growth of a friend. She had been to her first workshop, and her two week concentrated approach gave her two years of growth. I developed the practice of leaving home for a week or two each summer for emphasis on painting with no interruptions for household responsibilities. I paint with a passion away from home and despite the loss of conveniences in my studio, many of my most successful exhibition paintings were started or finished on these trips. And the expectations for each succeeding summer keep me going throughout the year. I return with renewed vigor and a fresh point of view.

Personal style evolves from constant work. The best definition for suc-

cess in art that I know is self discipline and a continual critical attitude towards your work. After a major commitment in time and energy has been made, other personal questions must be asked if you are not gaining a reputation commensurate with your abilities. Are you making a personal statement? Does your work represent you? Can others recognize it without depending on the signature? Are your subjects original or painted with an original viewpoint? Is this the fifty-seventh barn your audience may have seen this year? Are you adding something unique to a rehashed subject? Do other artists use this subject or technique consistently better? Perhaps this work is not yet ready to exhibit. Concentrate on improving what is unique and what you do best.

The six artists represented in this section illustrate the individuality of personal style even when attitudes, approaches and subjects are similar. There is no question all of these paintings were done by different artists.

Both Diane Faxon's "Rock Pattern" (page 74) and Margery Soroka's "Mountain Stream" (page 75) rely on a strong impression of a place. Whether real or imagined, they feel like specific places in which we might find ourselves. They both contain mostly hard edges, both depend on a previously created value plan, both are transparent watercolor, and both were conceived and painted in a single session. Why then do they feel so different? It is in the basic viewpoint. "Rock Pattern" creates a feeling of distance and space through the broken line which leads from foreground to open sea. The horizontal rock layers lead out of the picture as does the line of sea and trees which suggests that they extend forever. The light planes scraped through the rock add to the third dimension, playing up sunlit and shadowed areas.

"Mountain Stream" emphasizes flat forms, simplification of all shapes, and a closeup version of a place. The strong values lock the viewer into focusing on this small piece of river. One can hardly stop to wonder what is happening downstream from here. It is the intricate shapes that Diane Faxon chose to emphasize in her subject, contrasting with the simplified flat shapes which are the essence of Margery Soroka's painting.

Judy Richardson Gard's "Sea Structure" and Bonny Lhotka's "Sticks and Stones" capture a more generalized view of water and rock than do the two previous paintings. Both of these artists develop their acrylic paintings as they work rather than from a definite plan. They both use effects other than the paint itself to create strong textural contrasts. In Judy Gard's painting it is the addition of tissue collage, and in Bonny Lhotka's the subtraction of pigment. She rolls toilet paper over her painting to remove damp paint, creating a monoprint type of texture. Her choice of color and a way of underpainting the acrylic with alcohol give emphasis to the under pattern. Judy Gard's technique emphasizes the overpattern.

Diane Faxon

Margery Soroka

Judy Gard

Bonny Lhotka

Pauline Eaton

Laura Warriner

"Rock Pattern"
22" x 30" watercolor

Diane Faxon
Stamford, Connecticut

For Diane Faxon, rocks never cease to be exciting. Their strength and power, intricate patterns and textures, colors both brilliant and subtle, are an endless source of fascination for her. Here she has painted what she felt was the strength of this Maine Coast — the patterns of darks and lights, the seaward thrust of the rocks. She prefers her paintings to be a suggestion; a simple strong statement of nature's forms.

Painted on Fabriano 140 cold press, "Rock Pattern" was executed in one sitting to preserve spontaneity. The paper, with its fairly smooth, resistant surface lent itself to the hard edges needed to suggest the force of the rocks. Other areas were painted wet-in-wet, creating soft areas to give greater contrast to the hard edges.

Although not actually painted on location, it was done while the memory and excitement were fresh in the mind's experience.

"Mountain Stream"
15" x 22" watercolor
From the collection of
Edgar A. Whitney

Margery Soroka
New York, New York

Margery Soroka abstracts the character of a subject by designing with color and value shapes. She prefers to work on location where she can concentrate on the essence of the place with all her senses. Planning occurs before proceeding.

"Mountain Stream" was a direct, no-drawing impression of a difficult subject. It was accomplished by walking away from it after considerable staring at an impossible multitude of twigs, foliage, rocks and spray. She made a large light shape of the stream's path, containing it with rocks of different sizes and background tree mass. Grass, ripples and branches add calligraphic decoration.

Soroka wets her paper with a large soft natural sponge until it is saturated on both sides, then removes excess moisture with a squeezed sponge. Paint is applied in a fairly dry manner, with little water in the brush. This is controlled by dragging it over a damp synthetic sponge. Fast washes cover most of the paper. When dry, hard-edged washes, shapes and calligraphy are added.

"Sea Structure"
22" x 30" acrylic
and tissue collage

Judy Richardson Gard
Houston, Texas

Judy Richardson Gard finds it most pleasing to respond to a design as it begins to emerge. As she paints, she watches the shapes, textures and transparent color mingling until a theme appears. There are times when she plans a painting, but they are few. Imposing her conscious mind on watermedia seems to be a big handicap, and it's not nearly so exciting as just letting it happen.

"Sea Structure" was begun in 1974, but the greens and blues seemed too garish, and didn't "feel right". After a trip to Cozumel, Mexico in 1977, she found this start perfect in color to build an impression of the fantastic turquoise sea on the far side of the island. The whites were poured, splattered and directed to complement wave-forms which were established in the first attack. They were then tempered with glazes to complete the feeling of form.

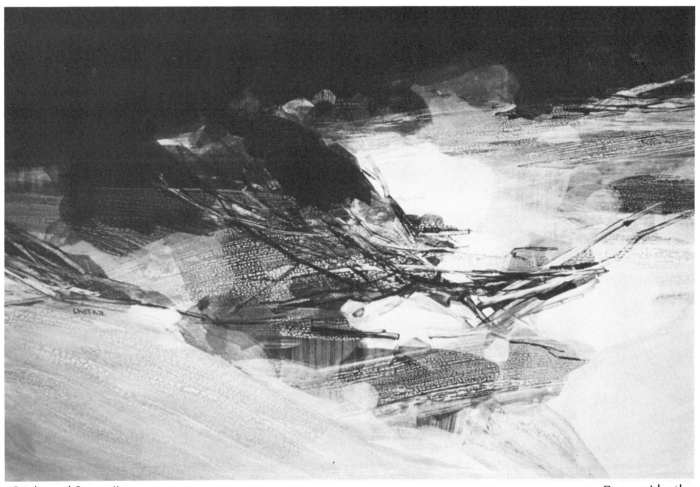

"Sticks and Stones"
*20" x 30" acrylic on
Crescent #1
Illustration Board*

Bonny Lhotka
Boulder, Colorado

Bonny Lhotka's paintings are distinguished by a textured, spontaneous flow with a pattern of interwoven layers. Often, the underpainting suggests a subject to be explored. A roll-off technique of toilet paper on wet, opaque areas pulls up some of the paint, resulting in simplified shapes and a translucent, layered look. Her paintings are a composite impression of places where she has been or imagined. They are expressions of feelings about nature's moods without being literal.

This painting was done from a series of photos taken along a river bank. There was snow, many exposed rocks and ice within it. Rather than choose the expected blues and cool color for a winter scene she decided to create an ambiguity by using reds, wine and rust colors with white. The painting was worked upside down and her reference photo was taped upside down on the wall. This helped maintain a more abstract quality. When the work was three-quarters finished it was turned right side up to complete. Many of the areas were painted first with alcohol, then while wet, gone over with acrylics to create the "bubble" effect.

"Spring Spectrum"
22" x 30" watercolor

Pauline Eaton
San Diego, California

Pauline Eaton's "Spring Spectrum" and Laura Warriner's "Life Pattern's" use two treatments of flowers to focus on differing ideas. "Spring Spectrum" insists that the individual flowers are examined. The focus is a close-up view, but what is seen within this closeup are intricate details. The use of geometric forms further emphasizes the focusing experience. In "Life Patterns" Laura Warriner is using flowers symbolically so that although the patterns are as intricate as in "Spring Spectrum", the intricacies do not magnify the flowers, but the mystery of them. It is the opposite of the focal point of view. The viewer's eye spirals and darts through the painting. Delicate shapes are emphasized by the dark and light patterns which weave an exciting path.

Pauline Eaton approaches painting by celebrating color, design and wonder. In dealing with the unique qualities of watercolor she uses the special merits of both the wet and dry approach to aid in her response to visual experience.

Her analysis of how we see the world is what "Spring Spectrum" is all about. We cannot take in all of what we see in one glance. Instead, the eye bounces through our visual experience, picking and choosing. The mind melds these interest areas into a whole impression. We may think we see it all at once, but actually we go through a process of integrating a whole realm of visual impressions. She calls these separate experiences "focal areas" and the whole experience a "focal painting." The background areas may be a blurred, or out-of-focus impression. The focal areas are the more tightly rendered buds and larger open flowers, combined with superimposed color to form a unified whole.

"Life Patterns" from
"Metamorphosis of Woman" Series
22" x 30" watercolor

Laura Warriner
Oklahoma City, Oklahoma

Laura Warriner primarily works in transparent watercolor but is not confined to it. She employs collage and acrylics as well. Continually on guard against complacency in working habits Laura periodically branches out into other fields such as ceramic glazing, weaving, batik, and fabric design. She believes each medium has influence on the other. She describes her involvement with painting flowers as follows:

"Realizing that society had imposed upon me the stigma of being something of a wallflower, (a pretty little thing that belonged in a group that had no identity except just to be part of the bouquet) I became aware that being an individual was what it was all about. The more individuality I saw in the flowers the more potential I saw in myself as a person. I also became aware of the fact that seeing — truly seeing — was the most important factor in my painting and the strongest stimulus. The excitement of investigation opened up my mind to learn more and to grow more,. Painting is the expression of my growth as a person. Now, my so-called floral paintings, to me, do not resemble flowers whatsoever. They represent the larger patterns and intricacies of life. This philosophy is the background of my series 'Metamorphosis of Woman' to which 'Life Patterns' belongs..."

Chapter 6.
Color Portfolio I

I have selected 15 artists whose works are immediately recognizable. The personality of the artist comes through without the signature being visible, and yet many of these diverse styles were created with the same attitudes toward painting. This common attitude is something I discovered while preparing this section. Although I am not really surprised, I had not expected this to happen. It has been a fascinating experience to read each artist's copy and find the words may be somewhat different but they are all expressing similar feelings. I chose these artists for their excellence, diversity, and courage. Perhaps the affinity for their work went beneath the product to the common view causing it.

I have tried to use the artist's own feelings about their work as much as possible. I have not given my own analysis of their work or injected any of my own thoughts on their pages, nor did I direct their response. Each chose to express what was important and I gathered and transcribed the information so that the written page is an extension of the artist. None of the artists described their painting in great detail. A common feeling exists that the viewer must participate and take what he will from the art, and not from the words.

"Paintings must be looked at and looked at and looked at... They must be understood... through the eyes. No talking, no writing, no singing, no dancing will explain them. They are the final, the 'nth whooppee of sight ...'Look at that!' is all that can be said before a great painting, at least, by those who really see it."

Charles Demuth

"Flight I"
40" x 60" watercolor

Carolyn Blish
Greenville, Delaware

Carolyn Blish has painted in a realistic manner for some time. "Flight I" is significantly different and indicates a new direction to her work. The freedom and grace of "Flight I" is directly related to the freedom of method which was applied and emphasized in this creative design.

There are two steps in this painting. First is the design which for her takes precedence always over the second, the subject matter. The design comes from flowing watercolor on wet, wet board. A garden hose is held in the left hand as paint is brushed and poured with the right. The board is tilted all ways to get a desired direction of flow, adding water where additional movement is desired.

Here is how the artist describes her painting process:

"It's a very exciting way to paint as everything happens so fast, and as I watch the spreading shapes of color, I madly preserve the precious white or negative areas, lifting the paint with spatula or sponge. (I not only lift with a sponge, I also paint with it!) Because the process is so fast and all virgin washes, the results are fresh and alive, never muddy, studied, or static. My imagination goes wild as I watch the streaming paint and start to 'see' things in the shapes. When I get a clue of something, I put the hose aside, and with the fewest possible brush strokes crystallize the idea.

"In this case it was a bird that came to mind. From the beginning, as I worked with the design, it suggested a winged feeling to me. Hopefully, I have captured the essence of the rushing speed of the bird with the oblique directional thrust.

"So, the end result is a gull that is not all facts but mostly fantasy. This mystery quality comes from controlling how much or how little the viewer is permitted to see, as the gull slips in and out of focus, here and there dissolving in the movement of fluttering wings."

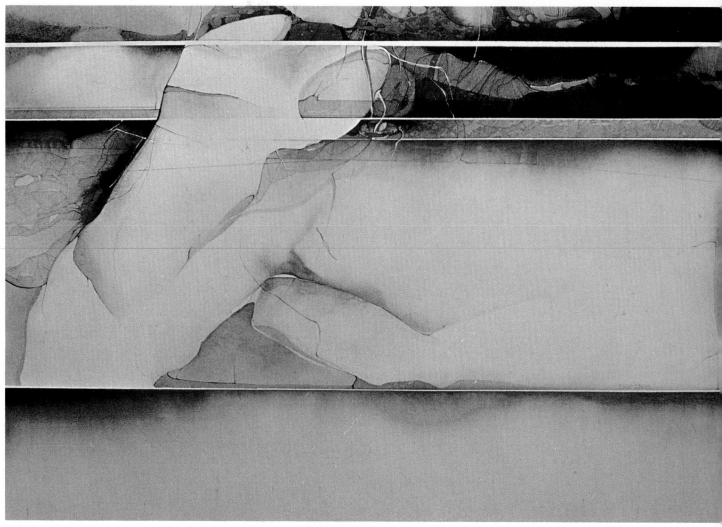

"Emergence of A Mole"
22" x 30" acrylic
watercolor on paper

Nanci Blair Closson
Tucson, Arizona

When asked where inspiration comes from, why she paints, or what a particular painting's meaning is, Nanci Blair Closson is unable to find a quick answer. She believes her work makes no profound statements nor harbors hidden meaning. Everything she puts on paper is a composite of visual experiences collected in her mind beforehand, so she admits to painting from very concrete and real things around her. Although the viewer may be reminded of something representational; a window, cobwebs, rock formations, the picture is never meant to be anything more than it is — paper with paint applied. She is intrigued by what texture, composition, form, color, and line can do to a piece of paper, and this is reason enough to paint.

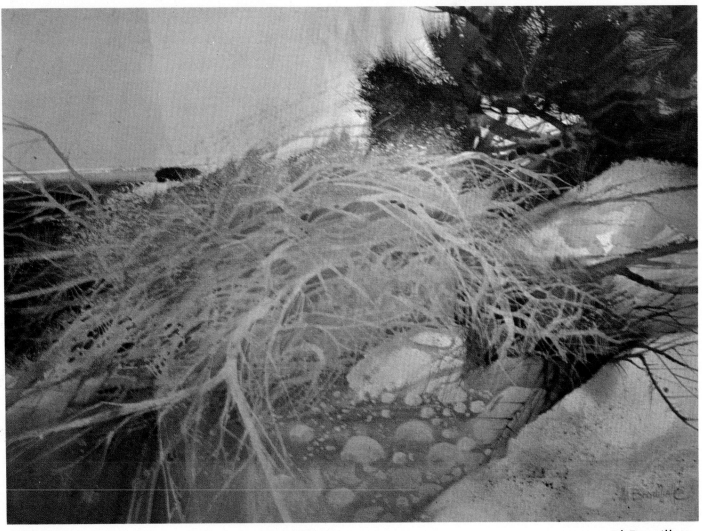

"Scrub Along Rush Creek"
20" x 28" acrylic
watercolor on paper

Al Brouillette
Arlington, Texas

Al Brouillette sets up no restrictions for himself by trying to figure out what his painting will look like before experiencing it. He leaves open the choices that might be presented as the painting develops. Otherwise, the possibility of finding new ways of expression would be limited, and the chances of repeating himself much greater.

He tries to leave himself open to what he might accidentally find in observing his subject. Improvising with charcoal on paper, Brouillette seeks to develop what he has seen into an original, personal statement.

Copying the charcoal would be just as restrictive as binding himself to the particulars of the subject, so the charcoal drawings and sketches are used merely as a means of mental preparation for the watercolor.

"Scrub Along Rush Creek" bears little resemblance to a particular place or thing. The subject is the infinite variety of line forms presented by the scrub. The one "reality" dealt with the application of water and color to white paper and reacting to each stroke as it was put down.

83

"Formations"
22" x 30" watercolor

Carl Molno
Woodside, New York

Carl Molno does not care to verbalize what he feels about his paintings. He prefers to have the painting stand or fall on its own merits. What is of utmost importance to him is that he loves art, believes all schools and ideas are valid, and does the best he can.

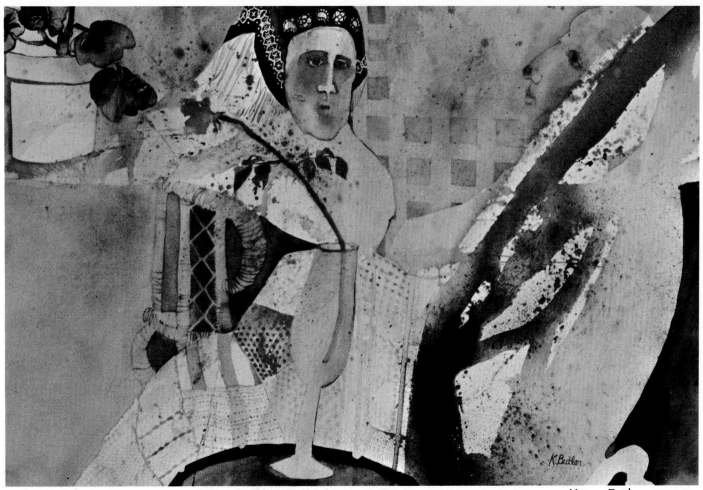

"Fresh Air And A Visit"
26" x 40" watercolor

Karen Butler
South Norwalk, Connecticut

Karen Butler chooses people predominantly, engaged in activities or in common places as her subject matter. She fully utilizes color, texture, shape, line and subject to create a distinct feeling or mood. Interactions of people are translated into colors that flow around and between. (In "Fresh Air And A Visit" the light tone is used to create a feeling of peace, relaxation and recovery.) Her colors can be bold and then subtle, changing in feeling as she responds while painting. A range of color will be selected to convey an idea.

Enamored of pattern found in such things as old china, quilts, wicker, and plant leaves, she weaves these appropriate patterns or textures throughout her paintings. Organic rather than geometric shapes predominate. The line is sensitive to what it is defining, changing from thin and delicate to wide and bold.

The paintings are usually begun by freely responding to color and shape. Then, after drying, the subject is defined and patterns established. During this middle period both a wet and dry approach are used. Finally, bold and free painting mark the finishing stage. A dunking pool is used to submerge the paper as the painting progresses.

Karen Butler prefers large paper. Full sheets are her smallest, and many are elephant and larger, cut from a roll. Her ultimate goal is in making a statement, usually a simple comment on human nature.

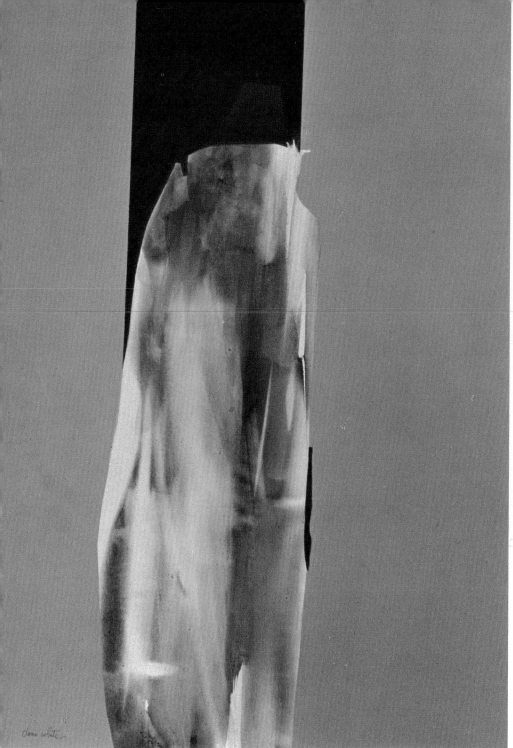

Doris White finds abstract art a matter of growth. Because painting is a visual process, one starts out seeing things the way they are. Then the artist can reformulate and digest the elements of nature and put his or her own feelings into the painting; instead of copying what is seen, something not there before is created. The hardest thing is to create something so simple and so direct that it leaves enough to the imagination. The viewer sees only form and color and doesn't recognize the thought process that actually went into it. The painting is not just what went into it, but all of the things that were consciously left out. The viewer should enjoy a painting for what he gets out of it without verbal direction from the artist.

"Divided Force" was one of a series of paintings in which Doris White was involved with using organic shapes, abstractly, or in fragments, to create the emotion of forces in nature. To emphasize this, she used transparent washes against opaque areas, and divided the painting with the intent of moving the viewer's eye through the center of the picture plane.

"Divided Force"
40" x 30" watercolor and acrylic

Doris White
Jackson, Wisconsin

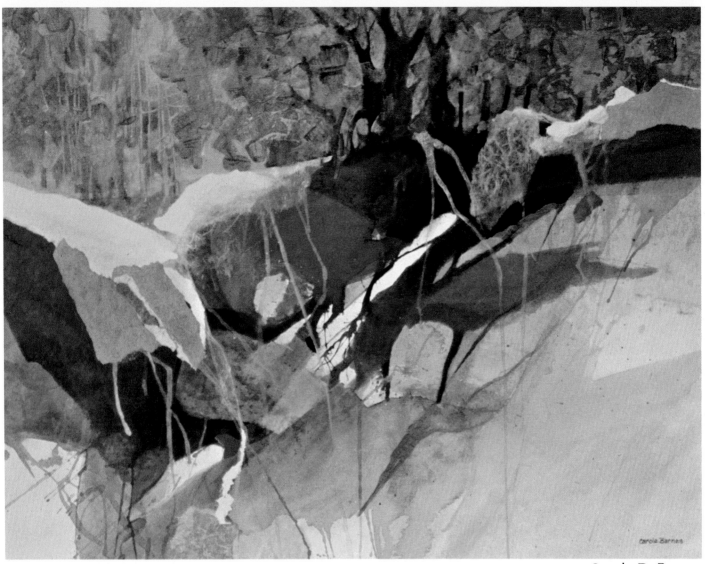

"Runoff"
*22" x 30" watercolor,
acrylic and collage*

Carole D. Barnes
Boulder, Colorado

Carole Barnes tries to capture the essence of nature, abstractly. Rocks, trees and landforms fascinate and challenge her to create a mood or feeling. She wants to see her subject in new ways, viewing it up close, from above, or even from inside.

Barnes begins with random colors and shapes without a preconceived idea of the finished work. After a possible composition is formed, areas are refined, breaking up spaces, varying colors and simplifying confusion. Each stroke and change needs evaluating to see if it goes with the rest and adds to the composition. Areas are enriched by using acrylic washoffs, spatter, drips and collage. Adjusting or redoing areas can take days or weeks. Usually several paintings are underway in different stages. Some are never finished and some are torn up and collaged onto others.

For years Carole Barnes painted in a realistic style, "getting in control"

only to discover the real excitement that comes from being "out of control." Now she works intuitively, letting the painting control her as long as possible to catch that new painting she didn't know was in her.

"Runoff" started randomly without an idea, with a structure appearing early. Shapes were blocked in with color and texture. Some areas were enriched with details, and others were simplified because they were distracting. The painting was turned and worked from all directions even though decisions had already been made as to which end was top. By turning, awkward design areas can be spotted. Acrylic washoff texture is in the background and collage bits distributed throughout. At the final stage drips and collage torn in thin strips were used to hold areas back. Rice paper added softer texture in the collage areas.

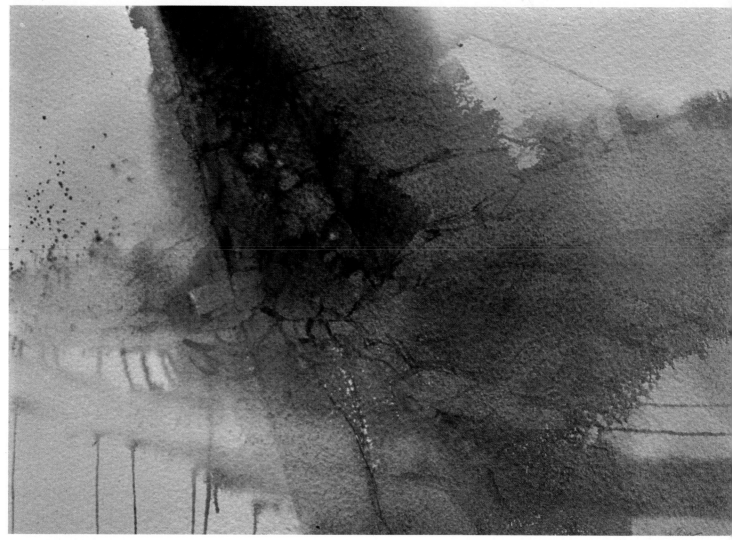

"Surfaces and Edges"
22" x 30" watercolor
Collection of Tijan J. Brook

Barbara Green
Barrington, Rhode Island

Barbara Green has great feeling for paper and simple statement. She enhances the textured paper by incorporating it with her subject rather than covering it up. All of her paintings are involved with space. Large triptychs only partially covered with paint have great strength. There is an exquisite restraint in many of her paintings. She uses a minimum amount of paint with optimum placement. No accident here, but the result of careful thought.

Surfaces and Edges demonstrates the use of a support to a painting (in this case the paper is a texture rather than just a surface upon which to paint). It is further enhanced by the use of subtle color and tone.

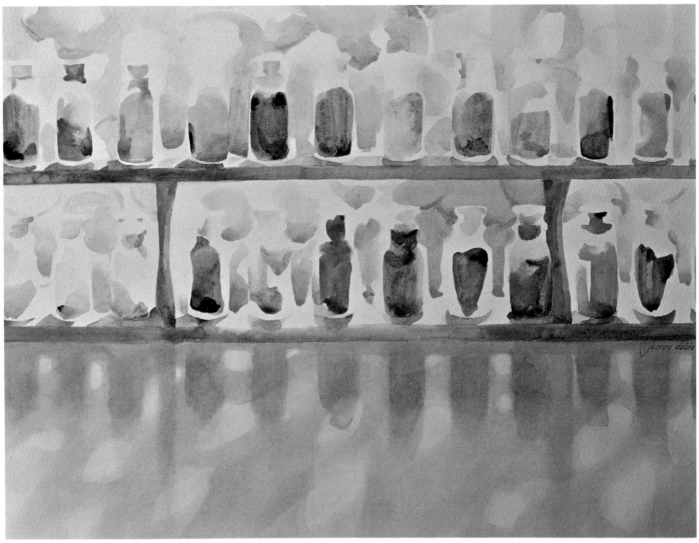

"Parsley, Sage, Rosemary,
and Thyme"
22" x 30" watercolor
Collection of Mrs. Betty Nagy,
Elburn, Illinois

Jeanne Dobie
Wayne, Pennsylvania

Jeanne Dobie believes that an artist does not need to rely upon a great dramatic scene, or a forceful light and dark design to attain a distinguished painting. She paints common everyday occurrences or subjects, elevating them to works of art, by adding herself to them.

She feels that life and painting are intertwined. An artist's background, associations, experiences, philosophy are all reflected in his work; and the combination that makes him unique as a person should make his art equally unique! The artist's goal is to achieve a painting that has CONTENT. Content should be "why" artists paint.

Jeanne Dobie enjoys drawing upon experiences or reactions stored within, that ignite a response to the subject and give it meaning. Each artist "sees" things in his own way. How much and what is selected or rejected is the artist's choice and can make the difference between a great painting and a mediocre one. She finds it exciting and challenging to work with ideas and concepts that transcend the actual duplication of a subject; to extract a "personal" painting from the ordinary things around her.

In "Parsley, Sage, Rosemary, and Thyme", the spice bottles were not the ultimate interest per se, nor were the dappled effects of the sunlight and reflective surfaces, beautifully dis-

tracting as they were. She could have chosen either of these. Instead she subjugated them to the concept of painting bottles without painting the bottles. The bottles were suggested by painting selected areas around and within them. As a result, a delightful interplay between what was painted and what was purposefully not painted was created, that enhanced the elusive quality of the sunlight.

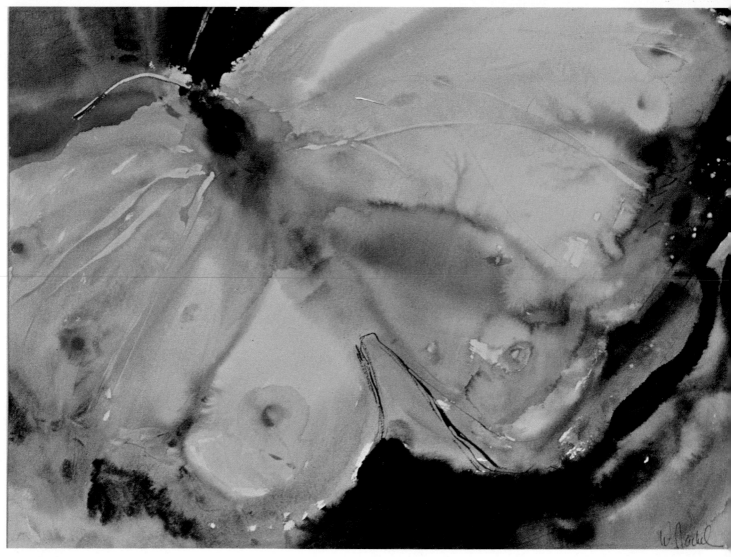

"Butterfly"
22" x 30" watercolor

Wendy Jackel
New York, New York

Wendy Jackel often chooses subjects which can be blown up and closely examined. Objects found in nature are treated loosely. Her subjects frequently include still life, flowers and birds in bright, strong color.

She works on very wet D'Arches paper, sponging the back and front thoroughly before applying paint. On this very wet surface, large amounts of opaque paint are brushed in. Using heavy paint and lots of water causes many surprises to occur when the paper dries. She believes that each new subject is a new experience which insists on a new way of working so that each painting becomes a learning experience.

The painting of "Butterfly" required many preliminary drawings to understand the subject. The subject dictates the technique. In this case, wet and moving, but still enough to identify. It's as if the butterfly had stopped moving long enough for the artist to paint and then continued on its way.

" 'Butterfly' did not just happen; it was an outgrowth of the preceding painting, as are all my paintings."

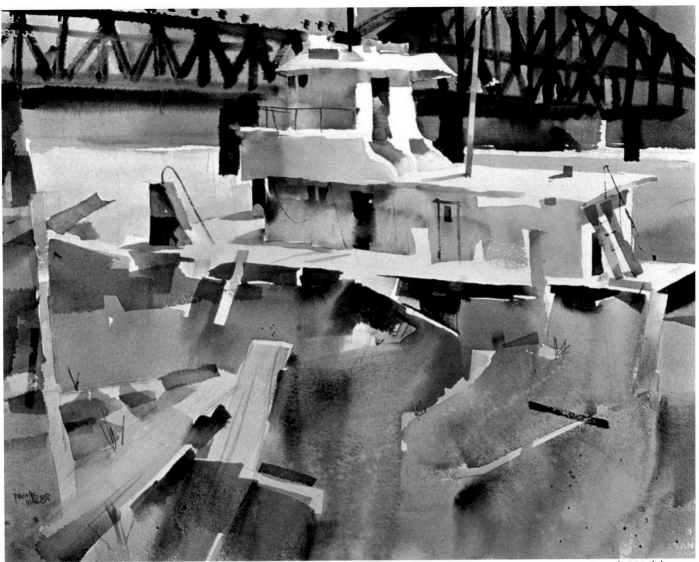

"Port of Pittsburgh"
22" x 30" watercolor

Frank Webb
Pittsburgh, Pennsylvania

For Frank Webb, the act of painting is a celebration, done in solitude, addressed to himself and to whom it may concern. It is another body of himself which contains meaning and it is dished up according to design principles.

"Port of Pittsburgh" was painted from pencil notes made on location. Standing in the actual world, he conceived it as a possible world and attempted to penetrate what was out there as well as what was inside himself. He believes that he can only see out there what he is capable of seeing. There is much more there than one person can see. Technically, "Port" is a purist job, painted wet-in-wet, mostly with a three inch flat brush on a good rag paper using finest paint. Speed of execution netted the following qualities: freshness, rhythmical relationships of the big pieces, breadth of effect, and a consistent mood in the fever-excitement of apprehending the content. Was anything ever created without passion?

In making this painting he hopes to hand on the feelings he experienced to others. This requires knowledge. It also requires much paper. Having a large supply of paper is like having a lot of tomorrows. Webb ruins many papers and would rather start a new one than embalm a bad start. For him the thrill is in the beginning. The culmination of his work depends on a good start. He would do it in a single stroke if he could. "Most people judge us by what we have done," he says, "we judge ourselves by what we think we shall be able to make tomorrow."

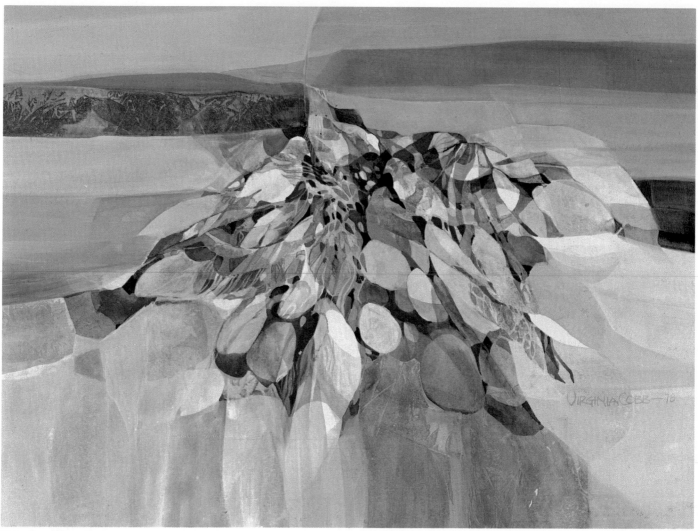

"Nesting Place"
22" x 30" watermedia
Purchased by Ranger Fund 1978

Virginia Cobb
Houston, Texas

Virginia Cobb's paintings are structural abstracts, based on nature. She is tremendously influenced by her surroundings. The colors, textures, and forms she uses are a reflection of her environment.

Having recently moved to Texas after twelve years in Colorado Mountain Country, her work and life are undergoing major changes. She finds it important to allow such changes to take place if her paintings are to be an individual and personal expression of her feelings.

The subject matter is seldom determined in the beginning of a painting, but allowed to develop. Most of her paintings begin as experiments with color, texture, and line. The results are not accidental however, but carefully controlled as the painting progresses.

When she selects a paper, decisions are already being made about the finished painting. She prefers to work with smooth paper when creating heavily textured areas in order to create her own textures. She'll work on irregularly textured paper when painting with transparent washes.

The paintings are constructed in a series of layers. Each layer is a complete unit allowing the freedom to carry a painting to any degree or finish desired. The painting is a thinking process and it is individual choices that make a work unique.

"Nesting Place" is a many layered painting, which began as an abstract design of rock-like forms. In the late stages of the painting the bird shapes appeared. At this point in a painting, subject matter can be defined further or eliminated. Here the birds seemed an integral part of the overall design and so the theme of a nesting place among the rocks was developed.

"Shape Scape"
22" x 30" acrylic
collage on masonite

Michael Rossi
Yonkers, New York

Michael Rossi has changed from a thorough planner to an experimenter, from reliance on nature to use of pure abstract forms, from transparent watercolor to mixed media, and from working a painting at one sitting to reworking and changing ideas in midstream. The thread common throughout his period of growth has been a dedication to simple shapes and strong pattern whether dealing with realistic or abstract material.

His aim is to eliminate everything that does not express the essence of his subject; to build a trap for essentials only; to arouse curiosity in the spectator by creating an air of mystery with interesting shapes, thus to entertain him, and get him emotionally involved. Since it is often easy to read landscape forms into a horizontal painting even if none were intended, he frequently uses a vertical format to shake up the viewer to experience shapes without feeling he must find a subject within the abstract forms.

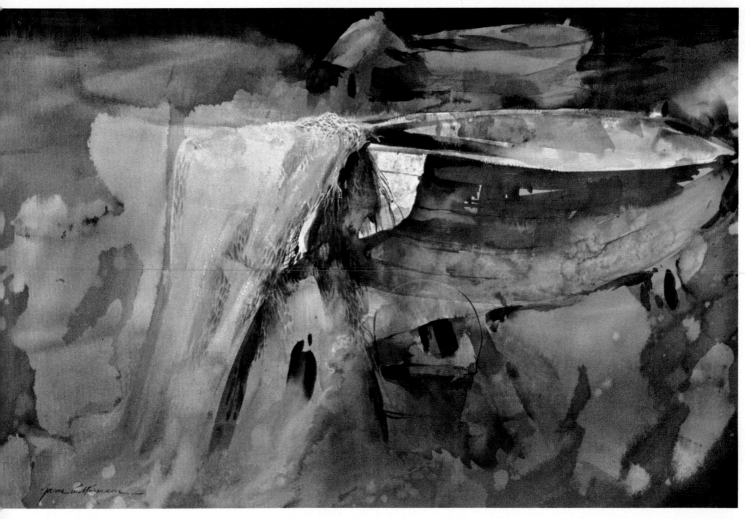

"Stegall's Wild Witch"
22" x 30" watercolor

Jason Williamson
Cave Creek, Arizona

Jason Williamson is an experimenter, drawn to watercolor for its potential. Generally he does not sketch, photograph, or work directly from subjects, relying instead on stored-up impressions. He may begin with a subject in mind, but tries to avoid any inhibiting factors and this includes use of a set color palette. Control is exercised at all times, but the unexpected is anticipated and then used if it is valid. Constant experimentation leads to growth and change, both, he feels, are essential.

One experimental approach consists of working directly on a smooth surface watercolor board, applying areas of color. Then, while they are still wet, a dry, broad house painter's brush is vigorously swept over the paper until the colors mesh, flatten, smooth out or create texture. Light areas can be removed or reworked by wetting and re-sweeping.

Other effects are created by monoprinting onto wet colors with paper, foil, acetate, cloth, etc., to manipulate the paint by pressing on and lifting off. Practice results in considerable control affording variable degrees of detail, if desired.

An interesting technique found in "Stegall's Wild Witch" consists of working on a rough surface watercolor board, painting directly, then completely immersing the painting in water. Some of the partially wet pigment flows off while some will remain. Further painting after the surface is dry, additional immersions and painting complete this process.

Williamson recently settled in the Desert Foothills of Arizona by way of Virginia and Tennessee, choosing this area for its stimulation and challenge. He feels the change will allow new directions and expressions of feeling, the touch-stone of his painting efforts.

"Twin Lakes"
30" x 22" watercolor

Mary Blackey
Glen Head, New York

Mary Blackey creates "mental landscapes" reducing the patterns of places to their simplest forms and filtering them through her personal vision. The places are not important in themselves. Only the feelings that they generate, her emotional reactions to them, and the design potential that they possess. She focuses on one particular moment or condition in time, reacts to it, and induces a mood through the use of watercolor. Considerations of design, space division and color relationships are her vocabulary in presenting an idea. She takes what is there and makes it more than it is by infusing it with a point of view while preserving the excitement of the original idea.

While working, tones are played against one another, forcing the forms to recede and advance. Layers of paint are built, each one a thin veil of color floating over the surface, in a structured rather than spontaneous manner, trying to maintain a lyric quality.

Visual excitement is created by painting "off-register" whereby the layers of paint do not quite meet, producing another tone. Nothing is formally balanced, but the end result will have a balance of its own. In trying to achieve a monumental quality, Mary Blackey uses boldly stated forms and an imagery defined by mass.

Chapter 7.
Color Portfolio II

The paintings in this section range from abstract to realistic, from strong color to pale, from strong value contrasts to subtle ones. They are more impressionistic as a group than those in the black and white subject section, and they are representative of what I like best in my work. Since I rarely work from preconceived ideas, my guidelines are few and most of my paintings are totally new experiences. Perhaps that is why I am elated when new directions appear. They are the result of my commitment to painting and its extensions. This is not a choice for me. I could not be otherwise.

Lejania
15" x 22"

Soft simple shapes, horizontal dominance varied by curves, and an unusual color choice mark this demonstration. It was painted in a straightforward manner from top to bottom. Notice the white, lavender and blue stripes on the extreme left edge. The paper had begun to dry after the wet brown horizontal curve above this was executed. The blue was put here as my element of surprise. A touch of the unexpected, echoed softly with a faint repeat of hard edged blue on the opposite side above the brown curve. The rest of the paper was rewet and the soft lower section floated in. The painting was still too timid so it was dried, turned upside down, and a bolder glaze of brown filled in over the sky to create two distinct value shapes and to emphasize these two shapes where the hard edge forms the top of the hills or dunes. By turning the page upside down at about a 20° angle I was able to control this edge without allowing paint to spill over my foreground.

Curious Yellow
30" x 22"

This painting began as a vertical with a definite center of interest start although I had no preconceived plan. The first few strokes were the yellows and darks on wet paper. A sponge was used to claim the edges of these shapes.

Basic decisions were made, the painting looked at from all angles, and I tackled the unfortunate textured triangle shape. By extending it to a square, it began to relate to the squared shapes at the top of the page. I flowed in strokes to cascade over it and found them too aggressive. A spray from the shower, addition of more paint, several subsequent sprayings and washouts resulted in the soft flowing feeling.

Starting again I tackled the lower left area with renewed vigor. I wanted to enclose some white within the painting. Then I deliberately matched the hues in the middle right square to create the new shape. I added similar textures, the two varied darker brown shapes for interest.

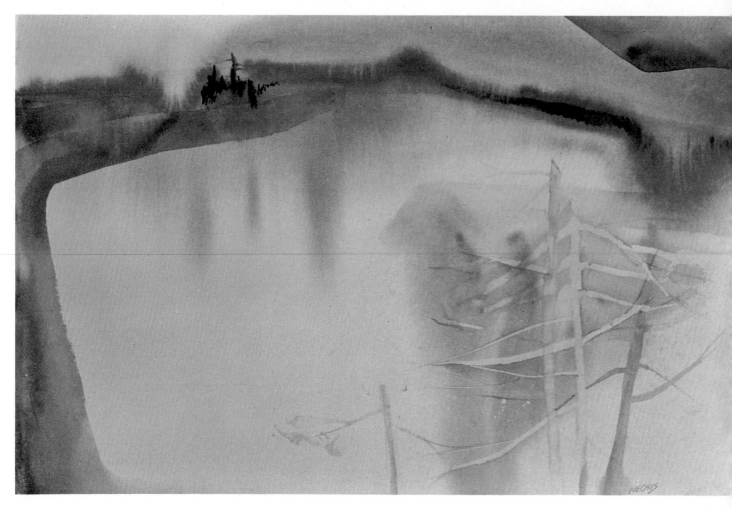

"Mirage"
15" x 22"

Most of this painting consists of white paper, but by painting such small shapes around only two edges, the white gives the illusion of having a very definite shape. This demonstration began with placing Winsor Red on wet paper, adding more for the more intense areas, and moving into tones of yellow ochre towards the left. The suggestion of dark trees was put in damp and then the paper dried. The upper right purple was glazed in to give form to a sky or mountain shape, and a darker value placed in it while it was still wet to add variety. The ochre brush stroke on the left was added next, and brought to the bottom of the page. Finally the emptiness of the vast white was softened by rewetting, adding pale pigment, and scraping through it for a tree effect. When dry, a few pale trees were added and some of the scraped edges toned to give more definition.

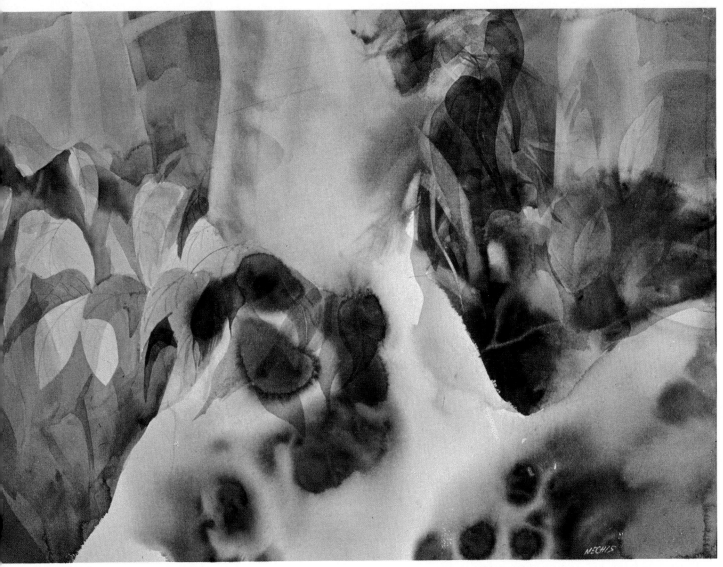

Saxon Wood
22" x 30"

The last stroke was placed on this painting almost two years after the first wash. There were many failure phases before completion. I stuck to it for two reasons. One, there were some unusual areas that were not quite like any I had painted before, and two, the versatility of the subject gave me many design possibilities.

My favorite areas are the first few strokes. After clipping a full sheet to my board I proceeded, as usual, by wetting the entire paper with a large brush. Then I mixed permanent blue and Van Dyke Brown Umber, and dabbed it full strength on the glossy wet paper. All of the round blobs at the base of the tree were done with this basic mixture, but drops of Alizarin Crimson and burnt sienna were added to vary the color. As the paper began to dry, I tilted it in varying directions to cause an edge to creep around some of the blobs as the wet pigment collided with the drying paper. Since the areas first painted were drier, they held their color, while the areas painted last were still wet enough to run. The result was the textural variety I wanted.

The hard edges forming the trunk and leaves were created by glazing. The top portion of the trunk was put in and washed out several times until I was satisfied with the final shape.

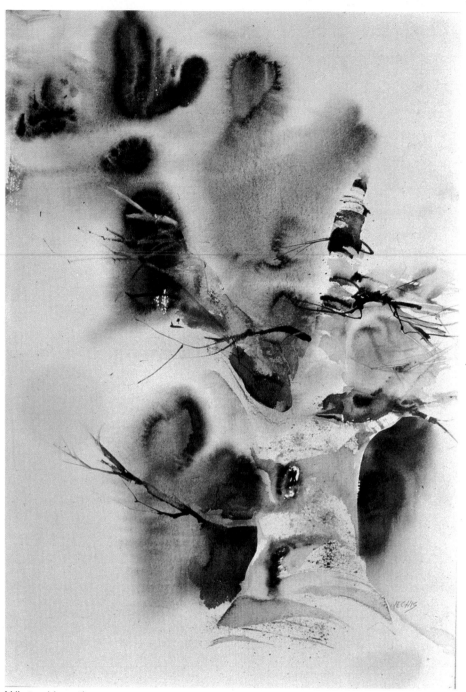

Winter Negative
22" x 15"

This was one of the first of my paintings to consciously employ oozles. I began at the upper left creating individual spotty shapes and flowing water between them to direct the eye towards the large white tree. Textures were dragged across the tree by using a scraper. Branches were knifed out and painted in, and when dry, the dark forms on either side of the base of the tree were painted to sharpen the image. The soft light pattern extends the tree into the background shapes to the right and above.

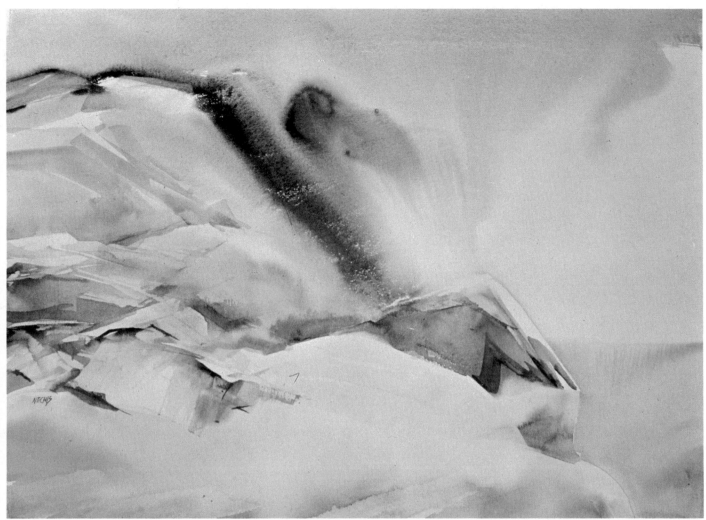

Spindrift
22" x 30"

A day of painting at Linekin Bay in Maine began with half a dozen wet, runny introductions. This was my favorite start and one of the few to make it through the finish by the end of the week. Had I been deliberately painting a sky, the odd shape in the middle would not have been allowed to occur, but this strong, large, central textured diagonal was precisely the characteristic that interested me and challenged me to continue. I finally decided to suggest rocky cliffs so that the dark would merge with the rock area and give the viewer a choice of the illusion of rock, spray, or sky. The foreground area was kept pale to contrast without overpowering the light rock above. The water to the right was added to echo the sky. When the paper was rewet, a subtle diagonal was added below the horizon to softly repeat the theme of the painting. Green growth was added for unexpected color change. A few corrections included taping and washing out the large midtone rock near the bottom right, adding dark accents, and correcting dark shapes at the top of the cliff. "Spindrift" still feels like that day in Maine overlooking the cliffs. And not a single rock copied from my view below.

101

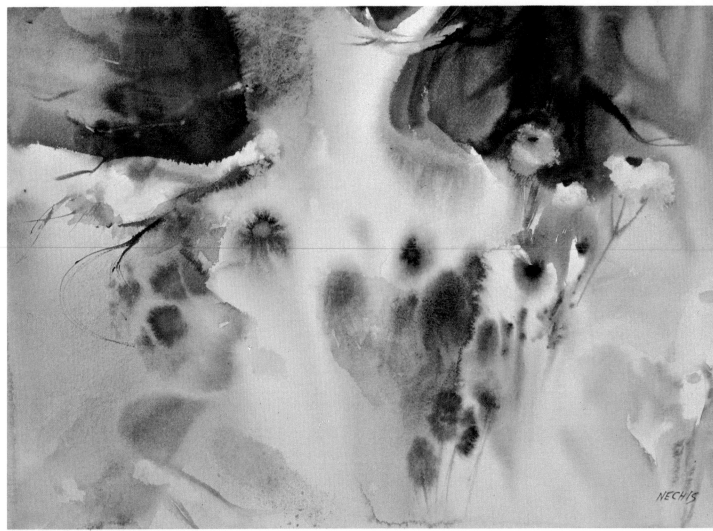

Woodland
15" x 22"

I see a woodland with flowers grow-
ing at the base of a large white tree.
The flowers were painted first using
the oozle technique. The tree was
formed by negative glazing. Notice
that the glaze does not hit the white
part of the tree. Other textures from
underneath form the shadow edges of
the tree giving it variety and extra
girth. Finally, a few flowers were em-
phasized and the pale ones at the
lower right glazed in.

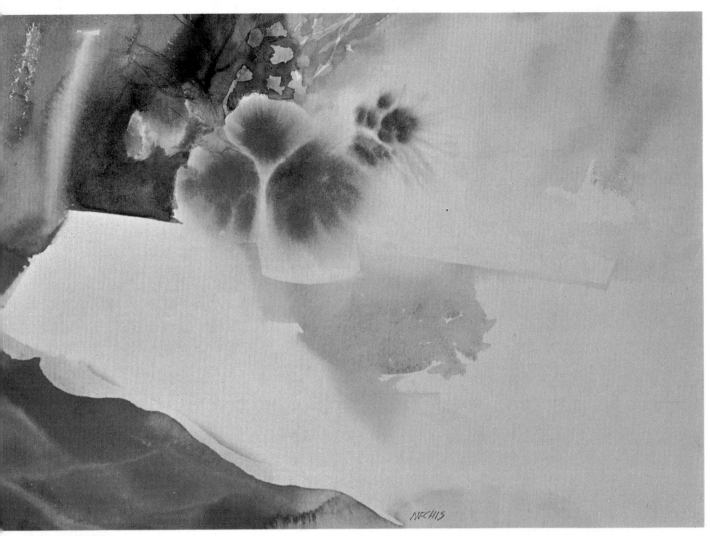

Sharon's Table
15" x 22"

I wanted the white to be the predominant shape. The red flowers were painted first on wet paper, with a soft background to the left. Gradually I worked my way around to the lower left corner which could represent a rug if the white represents a table, I created the table shape by scalloping the red with my scraper. Notice the variety of reds in the area of the rug. When the paper dried, I added the darker gray behind the flowers to create edges to the flower and table. I also placed small hard edged flowers at the top by glazing around the dried background. And, the shadows on the table formed the white vase shape.

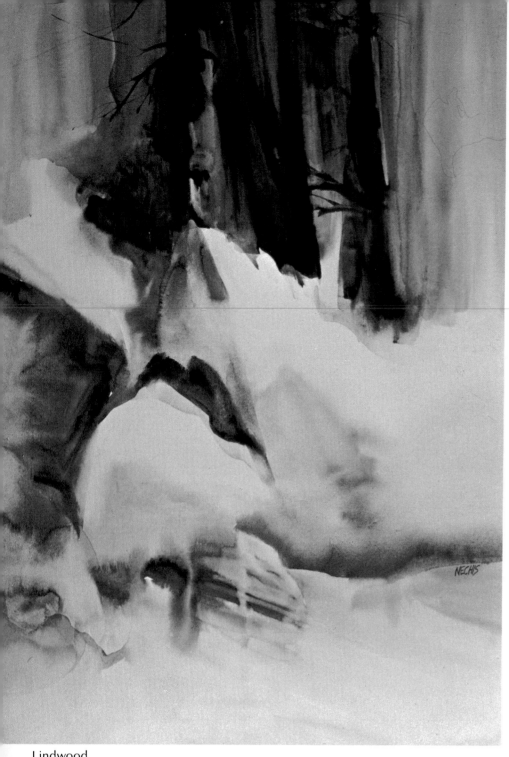

Lindwood
30" x 22"

Lindwood was painted on a porch at Boothbay Harbor. I was experimenting with Fabriano Cold Press paper and began with strong blues and purples to contrast with the white paper. Within minutes, the faults of this paper became apparent. Edges appeared out of nowhere on its smooth hard surface. (On hard surface paper applying more paint to damp areas can result in lifts of the earlier paint.) Since the paper was so unsupportive, I resolved to, at least, struggle through the painting as a design exercise and play up an interesting shape of white rock. I washed away the hard edged shape at the bottom of the trees using masking tape, and toned the areas on either side of the trees. Then I created the lavender puddled wash to the right of the large snow covered rock, added the water below. A few horizontal branches were added to cut the height of the trees. Perhaps this painting does not say snowy rocks, trees and water or ice to you. This is what I see in it, not what I tried to create.

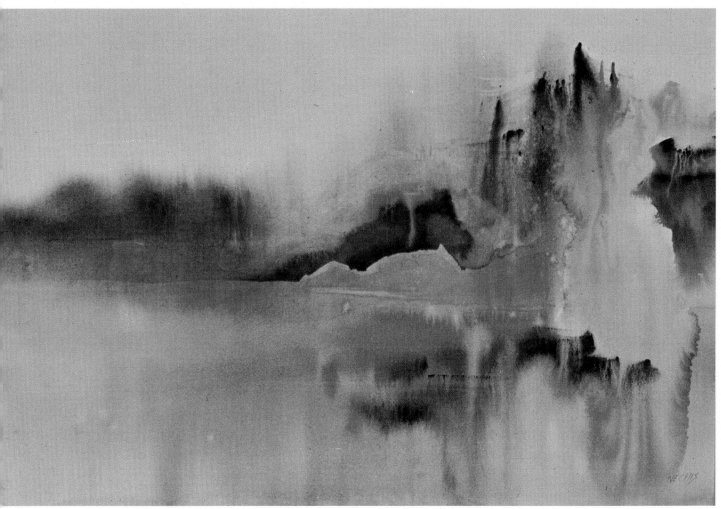

Cascade
15" x 22"

This serene landscape demonstra-
tion was started in the right hand
yellow shape; the yellow was stronger
and then spattered with water to
dilute and give it a foamy, runny feel-
ing. The orange area to the left was
one large soft shape. After the paper
had dried I added the dark center
shape to give form to the orange
below. The hard edged shape serves as
an extension of the initial yellow
shape. The top edge of the dark shape
was immediately softened for con-
trast. A thin glaze of orange was ap-
plied to the central shape to make it
less amorphous. Pale green was added
to the lower left for color change.

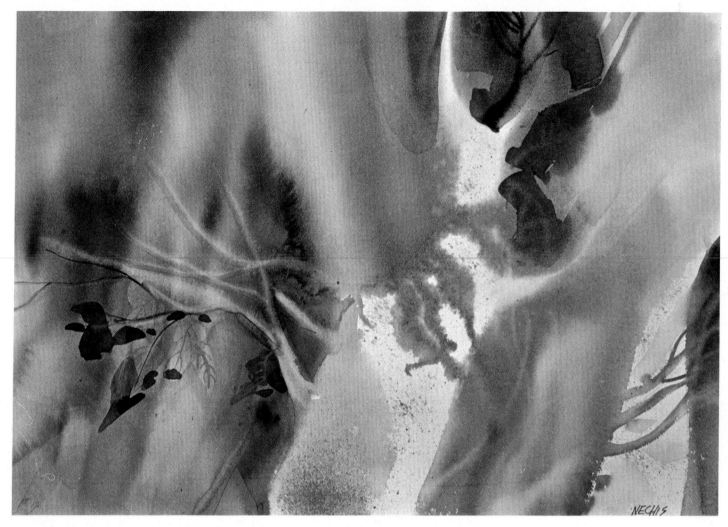

October Silhouette
15" x 22"

Interesting color and soft shapes with a few hard accents are the keynote of this negative of trees. Soft green drips across the white trunk suggests envelopement. The wet line drawing contributes to the softness.

Rivulets
16" x 12"
collection of
Mrs. E. S. Hill, Greenwich, Conn.

The paper was covered with soft wet washes and allowed to dry. Then, water from the faucet was splashed on it, and I tipped the paper to create drips of water. A pool of thin colorful pigment was flowed on the wet part of the paper. It travelled through the wet area to form a new abstract shape. The transparency brightened the colors underneath, yet formed contrasting hard edges where the color remained within the edge of the wetted portion. The painting was finally cropped and the upper right corner glazed in to suggest the roundness of the globe shape.

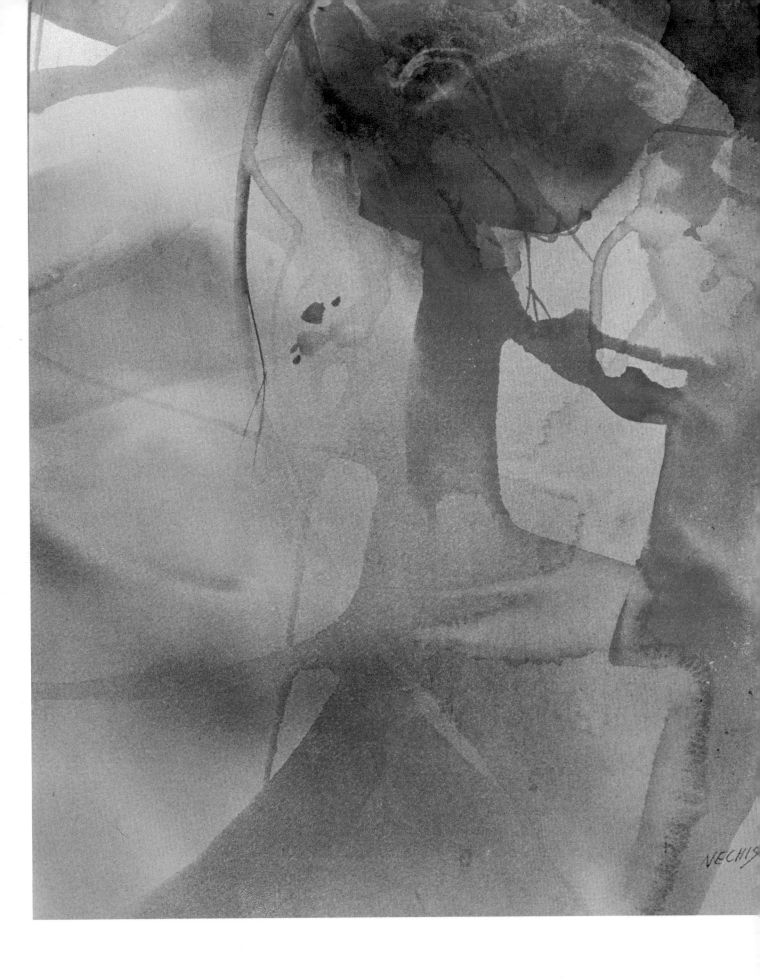

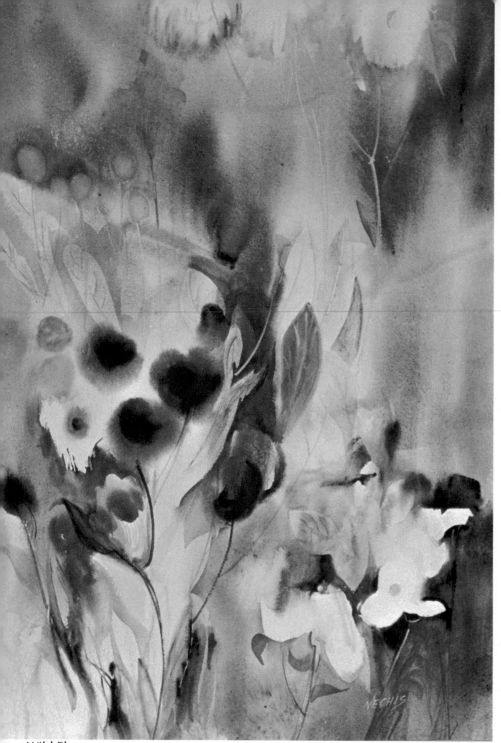

Wild Flowers
30" x 22"

This complex painting went through many stages of development. It has a center of interest start with the dark purple flowers as the first three strokes. Each was painted a cool red with a filbert brush, followed by a warm blue directly on top. The leaves were created by negative glazing around the warm green areas. The principle problem encountered was that the lavender wash in the upper section had many lights shot through it, giving a floating unfinished appearance. I needed the airy feeling and it would have been killed by laying a second wash. Instead, I created the flower shapes at the top of the page so that the whites became something specific. This area was linked to the rest of the painting with light yellow opaque stems. The curvilinear theme promotes movement through the vertical space.

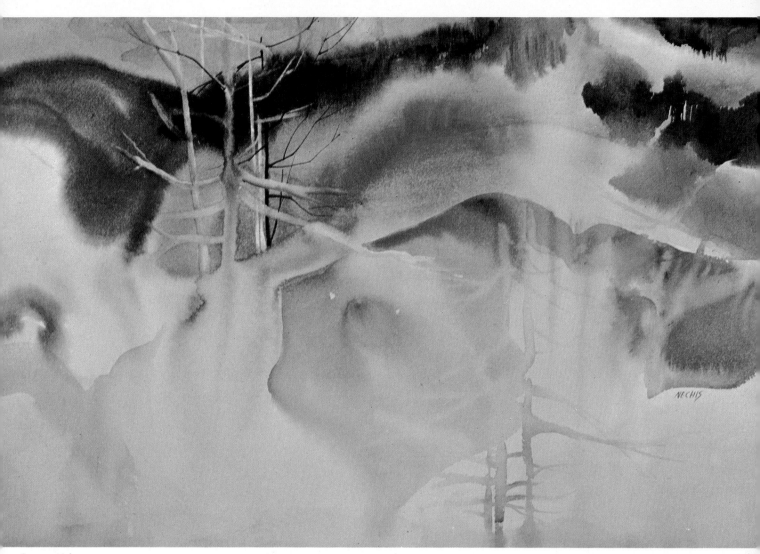

Sunnyside
15" x 22"

Each color shape was carefully defined in this landscape. The final area to be painted was the blue sky. The yellow sun was placed so that the drop of yellow below becomes an echo and suggests reflection.

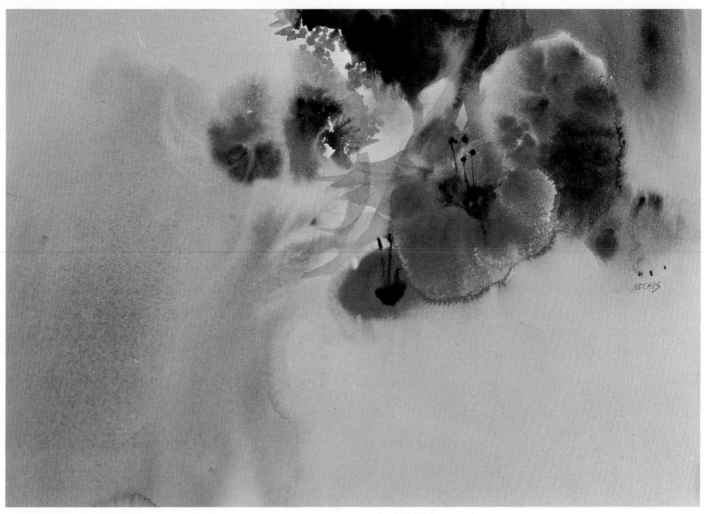

Spring Palette
15" x 22"

First came the bright flowers. With the paper re-wet and the large red flower beginning to dry, the board was tipped to create the bottom edge of the flower where wet and damp collided. The strong dark at the top adds focus and interesting space division. The details in this area allow the large, soft, empty space to act as a foil.

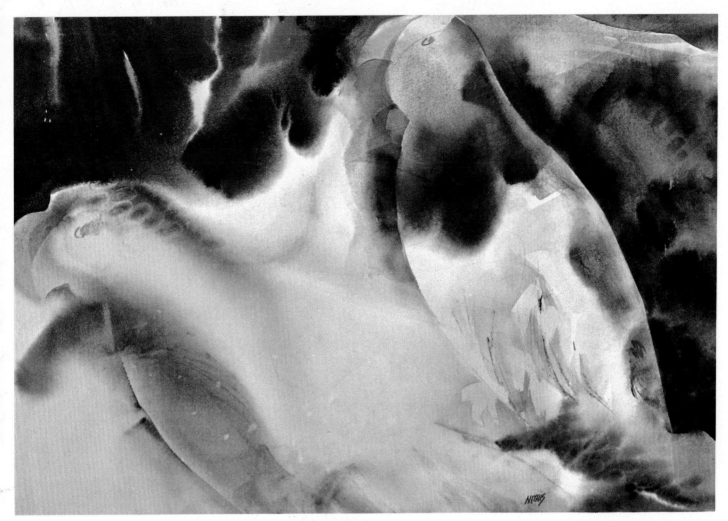

Parrot Pair
15" x 22"

Parrots emerged from the begin-
nings of a landscape painting. The
strong Prussian blue feels like velvet
and the bright green and red shot
through the background adds extra
vibrance to the cold blue. This com-
plex painting went through several
stages of development as shown in
step-by-step photographs on pages
116 and 117.

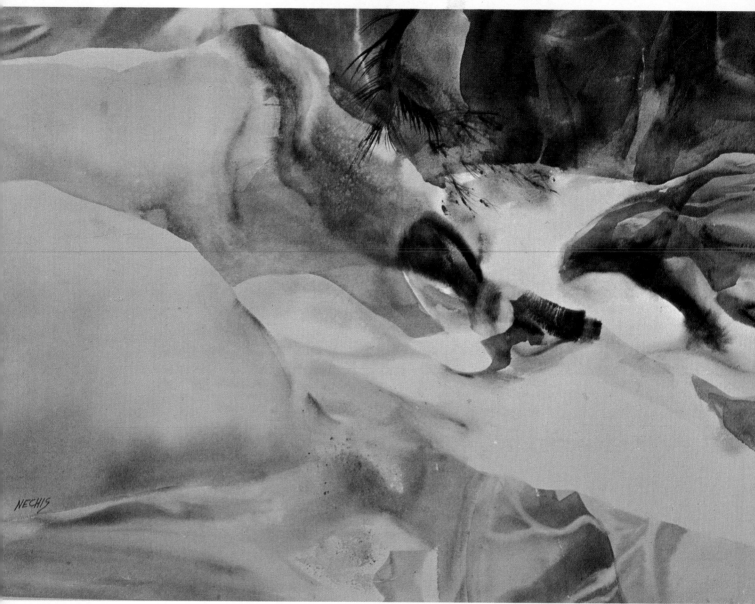

Pinebrook
22" x 30"

The final stroke on this painting gave me more relief than joy. It had many good shapes and interesting possibilities and so many problems. This two year effort began as a vertical tree. It could have become a vertical figure. When turned upside down, it suggested snowy fields. Throughout the painting the initial white shape remained. The background darks were added, washed out, and added again with less opacity the second time. The center dark rock was broken into two by taping and washing cascading leaf shapes. The large snow banks to the left were added, the sky area put in above and the water below. This painting felt as though it was 90% completed when, in fact, only the right two-thirds of it were painted. The left third from top to bottom took one and a half years to think about. It took half an hour to paint.

Chapter 8.
Completions and Fixing Failures

Finishing A Painting

Final details can complicate, enrich or kill. By now you must realize that each time a design change is made, it alters other parts of the painting, which in turn may need changes. Problem solving is extremely ego satisfying, but the solutions may take months. I work from problems, correcting all of the parts of a painting that I dislike. At a certain point I may be stumped. Then I prop the painting opposite my bed so that I will see it immediately on waking, and the last thing before sleeping. During the day I keep it near at hand to puzzle over. Occasionally it spends an evening next to the TV set where it may be watched more often than the program. It is rotated in four directions, and usually by the time the month has passed, several solutions have presented themselves. Sometimes, the most difficult solution will make the most exciting painting IF IT WORKS! If I have labored long and hard and need a winner for a show or for my ego, I may opt for the easy way out and choose the simplest solution. I wish I had the patience to repaint all of my troubled paintings to this point and then try the two, three, or four solutions that present themselves. Clearly this is the only way to know which is the best.

Flexibility is extremely important in original problem solving. A number of paintings began with one idea and a totally new direction is discovered during the painting process. Misty (page 43) was turned upside down. Pinebrook began as a vertical and ended as a horizontal (page 112), as did Forest PM (page 125). In Sapling (page 28) the center of interest switched from left to right.

The finish of a painting is usually apparent to me, but the degree of finish is optional. After the initial design works and there are no problem areas, spelling out final detail is a choice. Will any more additions make a difference from ten feet away? I constantly walk away from a painting throughout the painting process and view it matted and from a distance. Checking out a painting in progress may indicate that it is already finished. You must be comfortable with the completed painting. I am often comfortable sooner than other artists. I rarely face the danger of overworking.

If it pains you to destroy a good start, you are developing a feeling for paint. This is good. So is some irreverence. I developed a feeling for beautifully painted areas and consequently was afraid to finish many a good start. As the stack of unfinished work grew, I developed more confidence and realized that out of a group of beginnings some will be destroyed no matter how carefully one treads. By insisting on sacrificing areas for the sake of the entire design, the finished product will be better for it. If one part is significantly better than the rest, then it alone should be saved if it is complete by itself, and the rest discarded.

Prize winners have returned from shows and been put in the bathtub to scrub out an offending shape that went unnoticed. Others have returned and later been discarded. An artist should paint to please himself or herself. It is fine if others like it, but praise should not influence your feelings and make a painting precious.

Fixing Failures

Outrageous as it may sound, fixing failures can be great fun. There is nothing to lose, and unorthodox solutions can be tried. Students usually become discouraged and decide to begin again, but I like nothing better than to tear into a soggy overworked mass of muddy color and all over mid-tone values.

I have mixed feelings about working on student paintings and have set up certain rules for myself to handle this problem. I disliked having a teacher work on my paper and wanted to find my own solutions. However, I found that I learned a great deal from watching corrections of other students work. So, I keep my distance, but when a painting is about to be discarded I will step in, check it out, and go to town on massive surgery if needed. Sometimes I will only start a new direction for a student to finish. Ninety percent of the problems are value, and by adding dark shapes to contrast or regain the lights, and washing out small shapes of light, most pictures can be helped although not necessarily salvaged. Other frequent corrections are strengthening an area of interest, simplifying too many busy areas, unifying diverse color, and creating a dominant theme of shapes.

Occasionally each student will bring discards to class and an hour will be spent on corrections. The worse the painting, the more fun it is to slam in, knowing it can probably be improved.

Methods of Correcting and Completing Paintings

Rewet parts of the paper that need correcting, or wet the entire paper. If stronger values are needed and they are placed on dry paper, they will have a dry, dead appearance and will look pasted on rather than part of the original painting. Wet darks have life, dry darks are dull and two dimensional. Don't play it safe. Use strong paint and re-create new large shapes. Remember, if the paper is pre-wet, your additions can be washed off instantly. A painting is only unreclaimable when it no longer has any light patterns and the surface has already been scrubbed too much to permit any more lightening. The most constant mistakes are lack of contrasting values and uninteresting shapes. This can be altered by adding or subtracting paint.

Color errors are more difficult to fix. Pale colors are only effective on white paper. However, Chinese White and Naples Yellow can be applied over darker paint to lighten and add small details. See page 114. But if the colors are too garrish, they can be muted by adding a glaze of a complementary color to gray them. Washouts can also soften a color area. If a color is unpleasant, it is usually better to wash out the area as much as possible and apply a new color, than to correct it by painting over it.

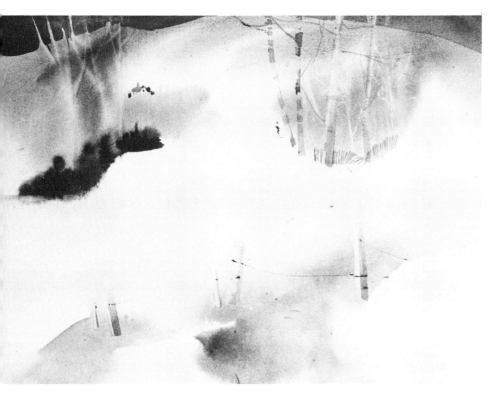

Part A

This was a class demonstration with the left shape of dark too strong for the rest of the painting. Some of the corrections in Part B are quite subtle but necessary to add finish.

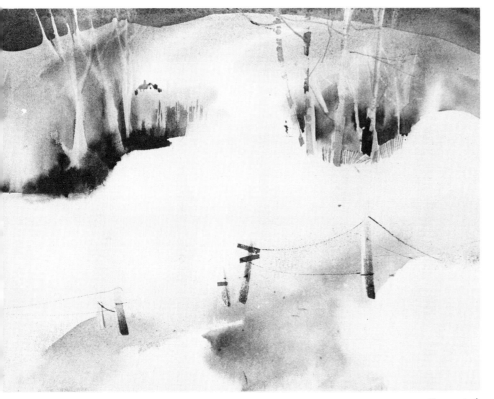

Snow Job
15" x 22"

Part B

The left and right tree sections were partially rewet, creating dry areas the shape of trees. Pigment was floated onto the wet paper to blend with the darks. A few darker accents were added to the right side for balance, and the glaze extended to create a hard edge to the white shape all the way to the right edge. The left dark was also extended so that the upper piece becomes a horizontal shape even though it is not completely defined. Finally the foreground posts were darkened, and line and extra spatter added.

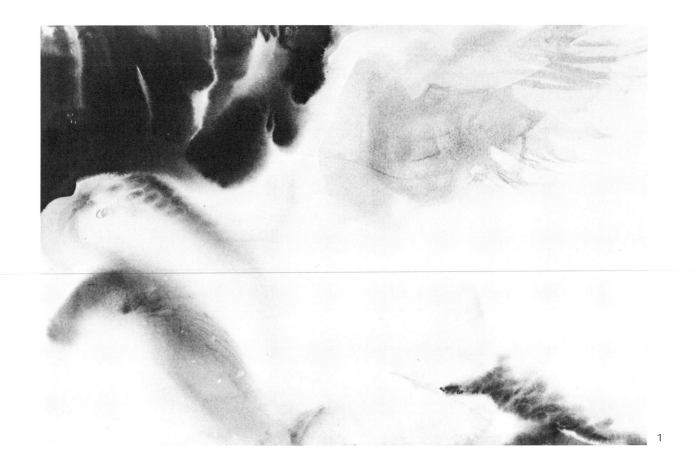

1

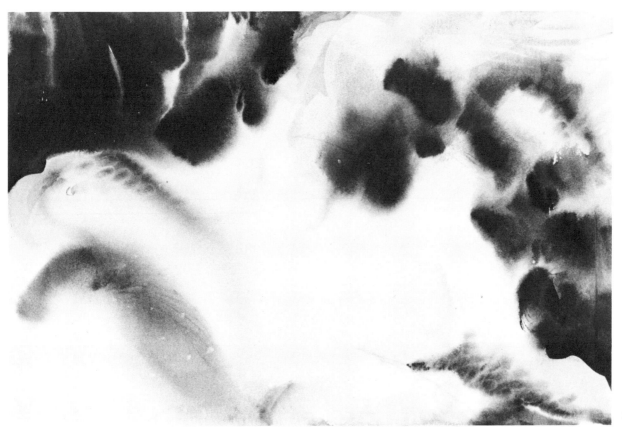

2

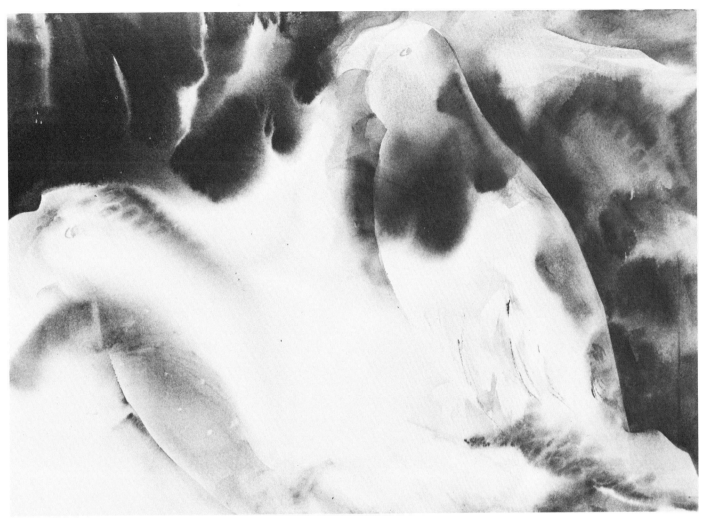

Parrot Pair
15" x 22"

Step 1.

This painting began as a landscape. As the dark form was placed in the upper left corner, its lower edge suggested the shape of a parrot's beak. I emphasized this form by adding an eye and fingerprinting feathers. This photo shows the upper right corner after it was scrubbed out as the shapes did not relate to the rest of the bird.

Step 2.

In the second stage the right area was rewet and Prussian Blue was added to echo the upper left. Freshness was reclaimed but the puffiness of the area competed with the rest of the painting and a new shape was needed.

Step 3.

The second parrot was added by negatively glazing a head and beak. Then I used a one inch aquarelle brush to carefully wet an area to form the right side of the bird from the neck to the bottom of the page. Several strokes of wetting and pulling up (lifting) the excess paint with my damp brush produced the hard edge defining the bird. Finally I glazed around the chest of both birds and washed the excess paint away. (see page 111).

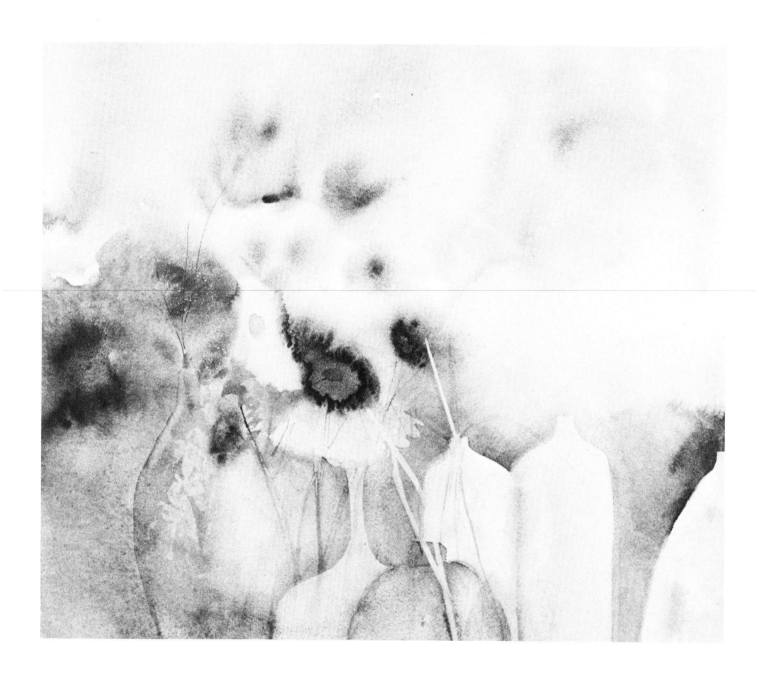

Step 1.
This unfinished painting of bottles and flowers sat in my bin for years. The right hand bottles were originally negatively glazed, and the left white bottle and stems washed out. Oozles suggest flowers and the bottle on the left was monoprinted with plastic wrap.

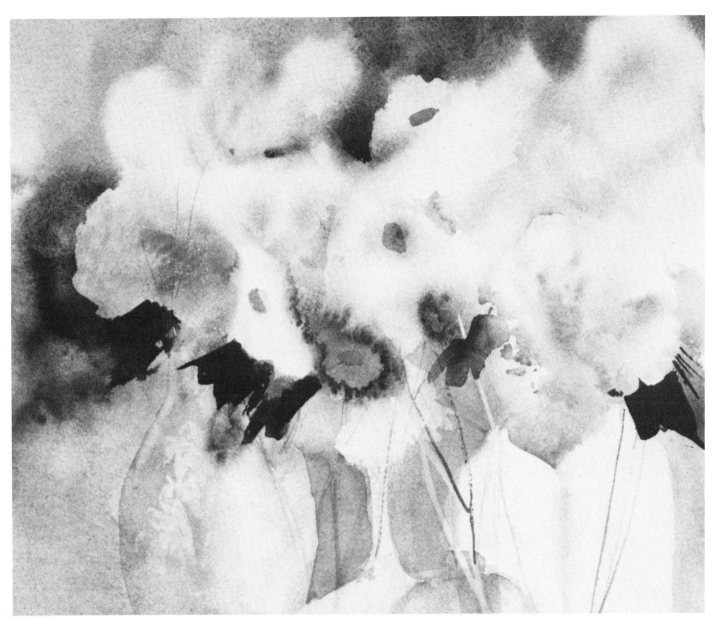

Bottles
15" x 15"

Step 2.
The area around the bottles was rewet
and stronger color floated in to lighten
the look of the bottles. The upper area
was then rewet and flowers were nega-
tively glazed to fill the space better.

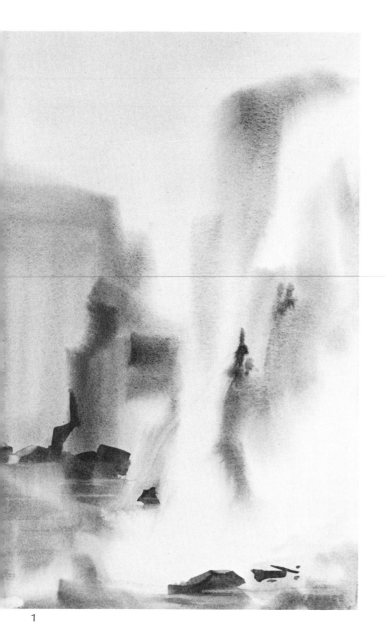

1

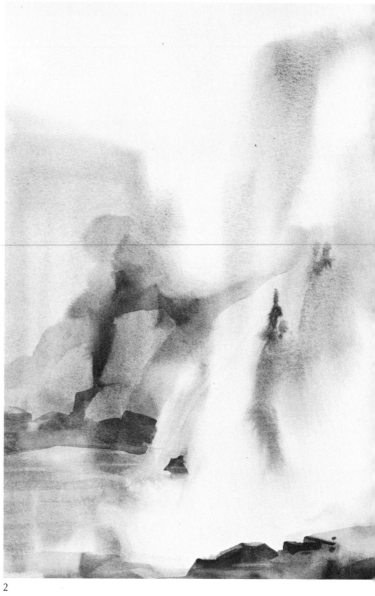

2

Step 1.

The basic shapes were placed on wet paper. As it began to dry, the darker rocks and trees were added.

Step 2.

The second layer ties shapes together and corrects the design. First the paper was rewet and soft oblique shapes were added to the left rocks to soften the large squared shapes. When dry, a hard edged mid-tone was placed over the rocks to enlarge them and continue them upward, forming both a dark shape and a negative light rock shape. This glaze was extended lightly across the top of the waterfall to give it definition and to link both sides of the painting together. A glaze also combined the rocks at the bottom of the page to create a shape rather than separate rocks.

Step 3.

The third stage adds drama and finish. The darks were added over the left rocks to raise the viewers eye. The dark was continued on the right side to enrich this area. Then the top section was rewet and a sky rewashed in to dramatize the whites below. Some rough brushing in the upper white area suggests another waterfall. Finally, details were glazed in the lower right area with rocks and water added to emphasize the white of the waterfall.

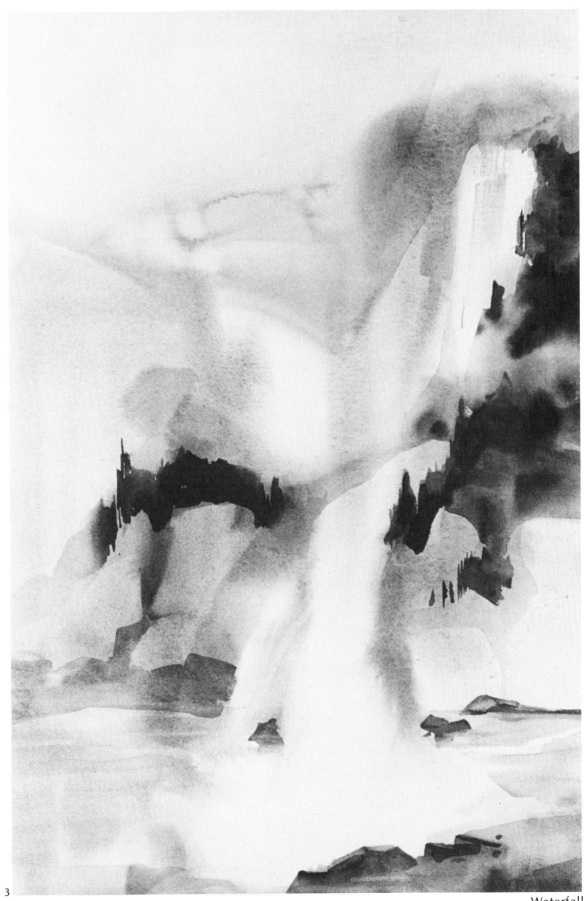

3

Waterfall
22" x 15"

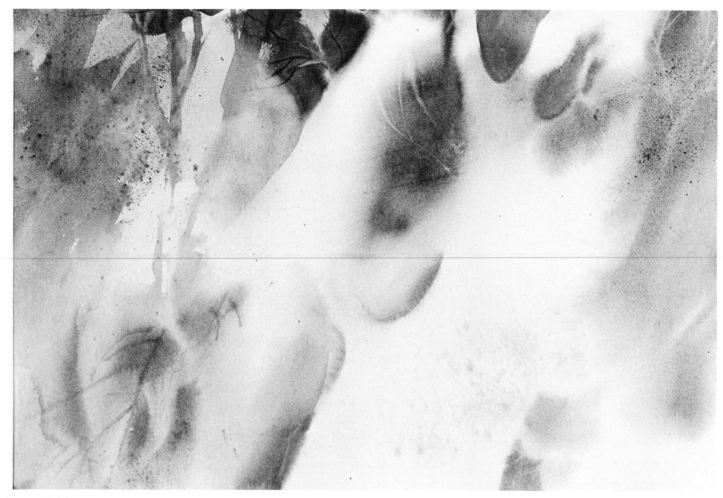

Forest A.M.
15" x 22"

This is a loose, suggestive abstract of trees and leaves. It could have been carried further, but I decided to leave it loosely defined.

Forest P.M.
15" x 22"

Step 1.
I began this painting with similar intentions to A.M. There were not enough interesting shapes to let the painting stand.

Step 2.
Dark, hard-edged shapes were added to strengthen the value plan. This addition adds form but the painting is even more incomplete and needs further development.

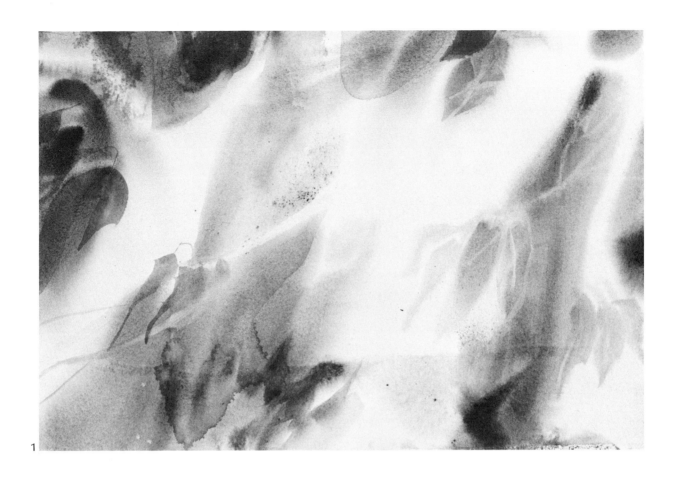

1

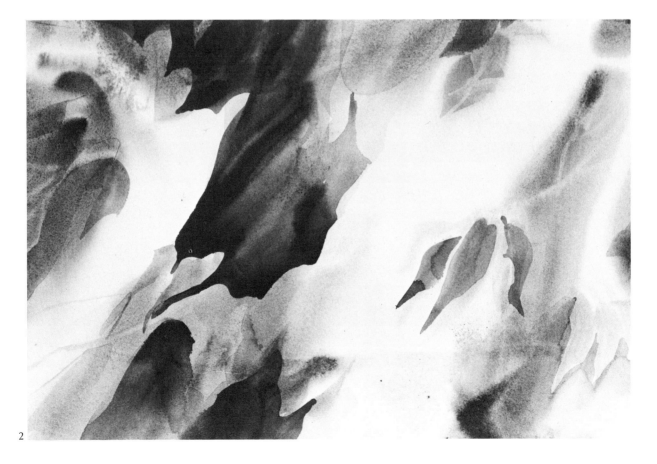

2

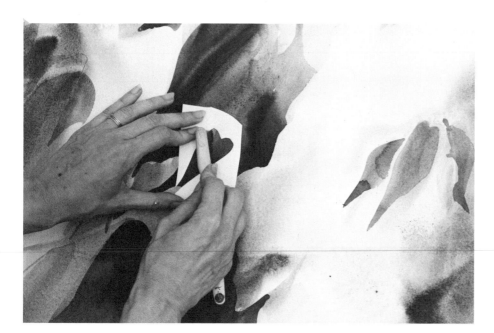

Step 3.
 Notice the two left hand leaves which were painted in step 1. Step 2 strengthens the shape by the dark wash around them. In step 3 a stencil is cut out and placed over the dark area to wash out additional leaves.

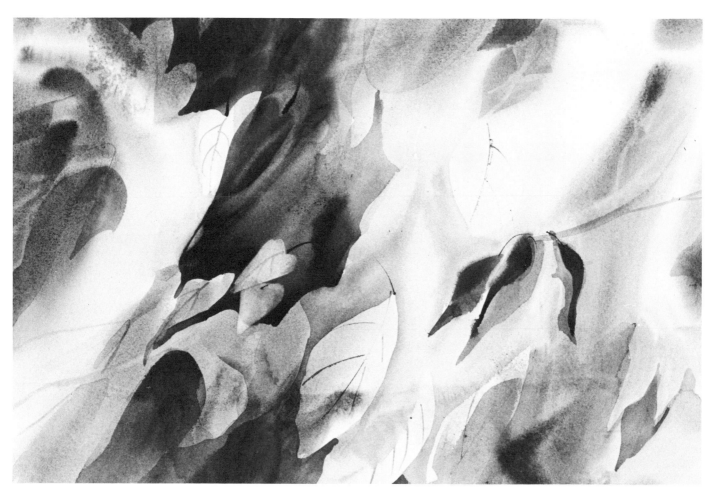

Step 4.
 More leaves are negatively glazed. The painting is being chopped up and still has no final direction although much of it has been decorated.

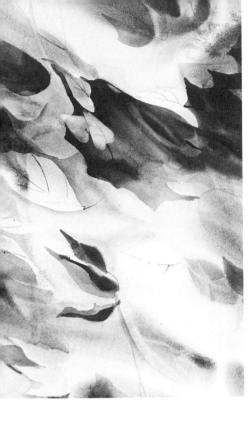

The same painting was turned vertically and new shapes discovered.

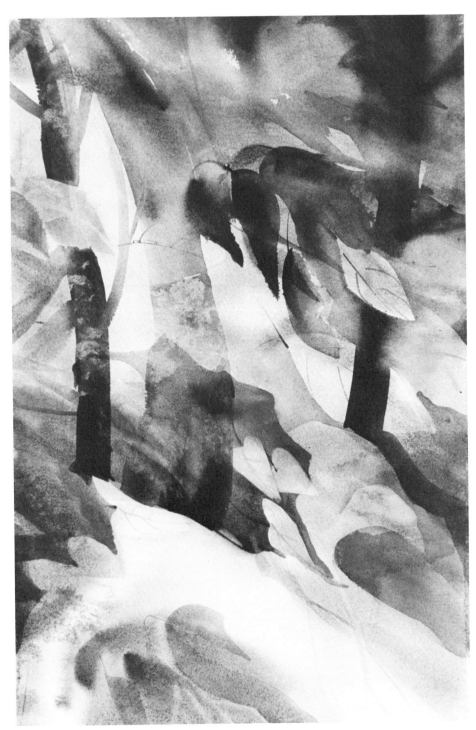

Forest P.M.
Final Step.
The entire paper was rewet. Soft midtone shapes were flowed in at the top to contain the light pattern below. Dark tree trunks were painted in allowing them to merge partially with pre-wet areas at the top. A few midtone glazes repeat the vertical shapes and tie the leafy patterns together. Finally, cloth monoprinting added texture to the tree trunk and center vertical midtone glaze.

Chapter 9.
Subjects

Each of the subjects I have chosen to illustrate can be painted in many ways and that is one of the reasons for my choice. If I were to illustrate how to paint a rock, fence, or blade of grass, it would be making a statement of how I paint these objects. Not only is this information useless in teaching how you should paint these objects, but it is detrimental. It presumes that there is only one way of painting rocks so that you and I will both paint rocks alike. How dull! As a beginner I learned to paint many things by watching my teachers demonstrate. Some of these things were so thoroughly ingrained, that I never developed my own way of doing them to satisfy me sufficiently. For this reason, I avoid a few subjects which feel like clichés. My vocabulary is personal, but certain subjects are so much like successful formulas that I avoid them. Students will ask, how do you paint surf and rocks? When I demonstrate effects such as these, I try to use a variety of methods, rarely using the same one twice, to encourage students to discover their own. "Spindrift" (page 101) is one of my favorite rock paintings, but I wasn't consciously painting rocks, and I have no desire to repeat those particular rocks in the same manner. Vladimir Horowitz says he never plays the same piece the same way twice. He believes that everything one does in the arts should be spontaneous. I agree.

Choice of subject matter is most important. It is easier to be creative with some than with others. The various subjects which I have selected to explore have all been of interest to me at some time. Just as the style of my work has evolved naturally through experience, so has both my choice and treatment of various subjects. Some are easier for me than others and it often feels like play when I return to a familiar theme. Others, which were once so special, I no longer have the same feelings about and as a result I am unable to do as well.

Some subjects can be easily explored by everyone. Others need more specific knowledge. I will explore the most versatile first.

Landscape

My landscape forms are not always concerned with reality in nature. While painting I get excited by shapes. Color shapes, value shapes, negative shapes, are often arbitrarily placed and then new shapes are added to relate to those already placed. When I begin with the subject of landscape in mind, I usually start fairly traditionally, with a sky wash at the top. However, any color on my palette may be chosen for this area. The next layer is placed below the sky, as I work my way down the paper. However, at some point, my attention may be taken by a texture or form which may send me in another direction.

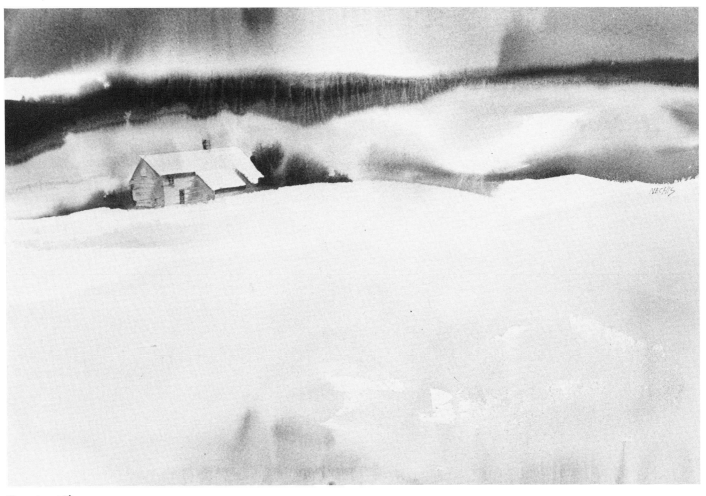

Country Life
15" x 22"
Collection of
Mr. and Mrs. Arthur Kramer,
Copake Falls, New York.

Painted from the top down, the unexpected in this painting is in the color rather than subject. Oranges and pinks are unusual in a scene suggesting snow which this one does when seen in color. Still, the scene is familiar with horizontal dominance and a high horizon spacial division. The rooftop was scraped out and then glazed around for emphasis.

Manor Park
15" x 22"

My version of a familiar scene painted from Horseshoe Harbor. The Gazebo, a local Larchmont landmark is left out so the scene could be anywhere. Notice the horizontal dominance created by the clouds and trees. You cannot tell where the one ends and the other begins. The light shape of ground shows up softly against the sky which is only one value shade darker. Rock, water, and sailboat shapes repeat the horizontals.

Hill People
15" x 22"
Collection of the
Butler Institute of American Art,
Youngstown, Ohio.

Again the landscape is suggested rather than familiar. The place could be a fantasy. Texture was achieved by scraping, knife printing, and rough brushing. The figures were knifed in at the end. The fantasy is further promoted by unusual color choices. A bright red is washed in parts of the sky and repeated in the architectural forms in front of the large hill shape. Grays and browns complete the palette. �─

Blue Shape
15" x 22"

The first two landscapes were traditional subjects with a horizontal emphasis. In "Blue Shape", landscape forms are distorted and merged without being spelled out so that the viewer can complete the concept.

While painting, the large shape reminded me of both a tree trunk and a cliff. Rocks and water are set against it. The long curving crawl back repeats the curves of the large mass.

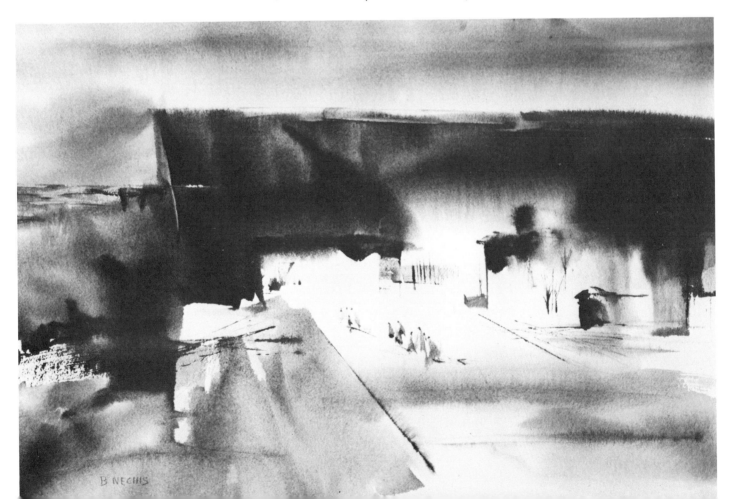

Snow

There is more variety in my snow paintings than all of winter. My versatility in this area may relate to my love of white space. Some of my snow scenes cover most of the paper, giving the illusion of white where little exists, and others make use of white paper so that little paint is needed. Snowy trees, ski slopes, evenings, villages, country churches and abstracts have all been explored. I try to keep all of them as fresh as the snow itself.

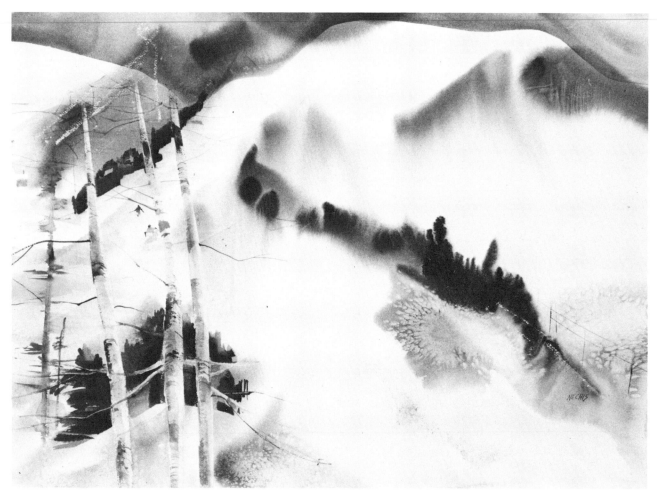

Mad River
22" x 30"

The freedom of skiing is captured by using wet flowing blue shapes, salt and spatter. Structure is accomplished by glazing hard edged shapes. The wash is allowed to leak under the edge to soften the effect. The birch trees were scraped, taped, washed out and painted in.

Evening Slope
13" x 22"

The soft midtone in the center of the painting extends along the top of the page and was the first shape painted. Wet line drawing produced the trees in the upper right. The paper was dried and then strong pigment glazed over the top shape to form a hard edge. It does not cover the entire soft shape. The wet line area was partially glazed to harden some of the tree shapes. Birch branches were knifed out, the trunks scraped before the area was dry, and accents painted in later.

Detail

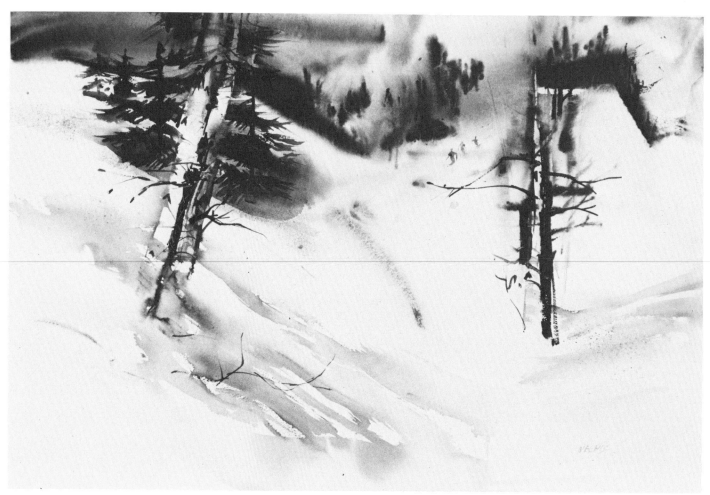

Blue Hills And Skiers
22" x 30"
Collection of
Mr. and Mrs. Morris Simkin,
Chappaqua, New York.

Blue Hills was painted on very wet paper with much Prussian Blue pigment. The foreground was partially rewet to create edges where the brush strokes overlapped wet and dry areas.

Carving a shape — Many of my ski paintings depend upon an unusual shape. Deliberate distortions add interest. The greater the exaggeration, the more the interest. The edge at the left was painted around. At the right, it was scraped out.

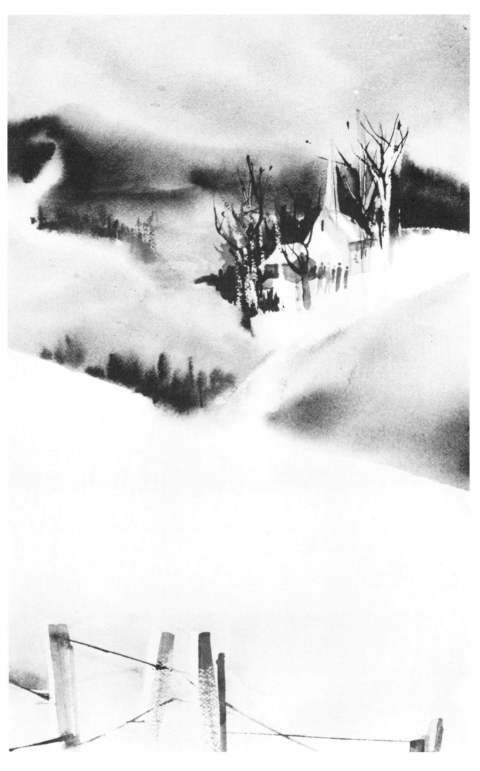

Country Church
22″ x 15″

Strong diagonals tend to widen a narrow picture shape. The rough brushed fence posts frame the painting. A suggestion of trees spilling over the white diagonal near the center softens its edge and adds interest.

Flowers

Flowers are one of my favorite subjects for many reasons. First, I became attracted to them most recently. None of my teachers liked to paint them and so I avoided them thinking they were too difficult. Nothing could be further from the truth. It is easier to design with flowers than with any other subject. If your design needs a dark in a certain place, add a leaf. If it needs a light, glaze around to create a new light shape, or wash one out. In landscape you can't always arbitrarily add a light or dark because the design needs it. It may not fit in with the subject. One of my joys in flower painting is that I have never studied flowers. Had I been a botanist I probably would never want to paint them. A flower itself is more beautiful than what we can put on paper, but oh the joy of inventing new ones. What a glob of gorgeous color on wet paper can create. Many of my flowers were created on wet paper and they resemble the real thing, but a gardener will have to tell me their names. The variety in flower painting is enormous from color to size and shape. It opened up a whole new range of subject matter for me to explore for a lifetime.

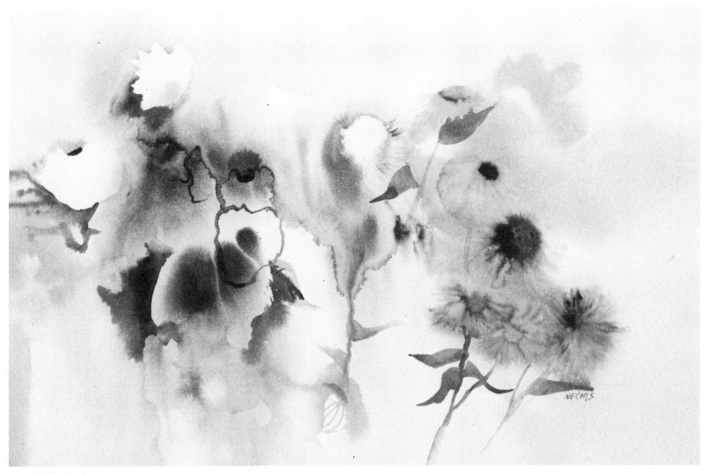

Handful of Flowers
15" x 22"
Collection of
Elaine and James Jacobson
White Plains, New York

The flowers on the right were painted first while the background was still wet. The petals were done with Naples Yellow. This heavier pigment held its shape, causing interesting edges where it merged with the background wash. Flowers at the left were glazed around, a few darks added for emphasis. And last the leaves and stems were painted in. The curved line was a drip dragged into a flower shape with my fingernail.

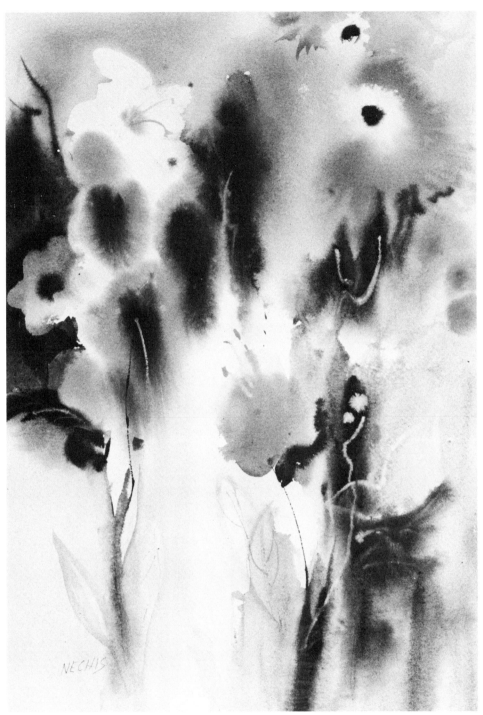

Perennials
22" x 15"
Collection of Joann Brown,
Mamaroneck, New York.

This was painted clockwise, starting
at the left, touching all of the wet
areas first. The white flower was
strengthened and some light opaque
stems finished the painting.

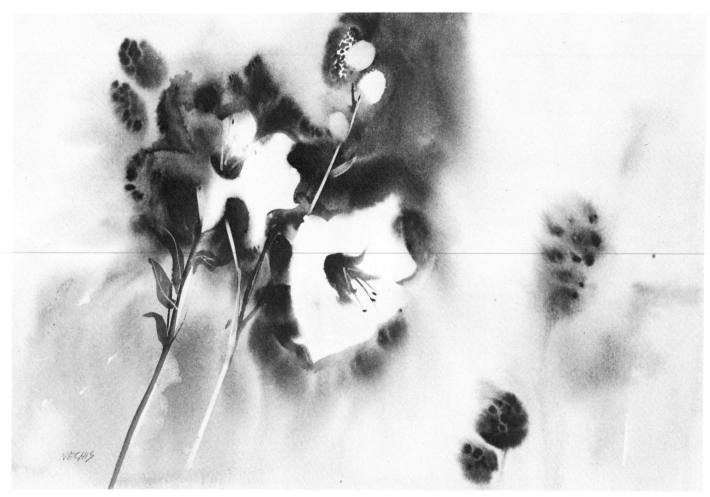

Blue And White
15" x 22"

The white shapes were left untouched in the initial wash stage. Glazing marked the edges of the flower when dry. The small white blooms and stems were stenciled and washed out. The flowers that look like grape clusters were painted with a round brush touching each dot of paint to damp paper.

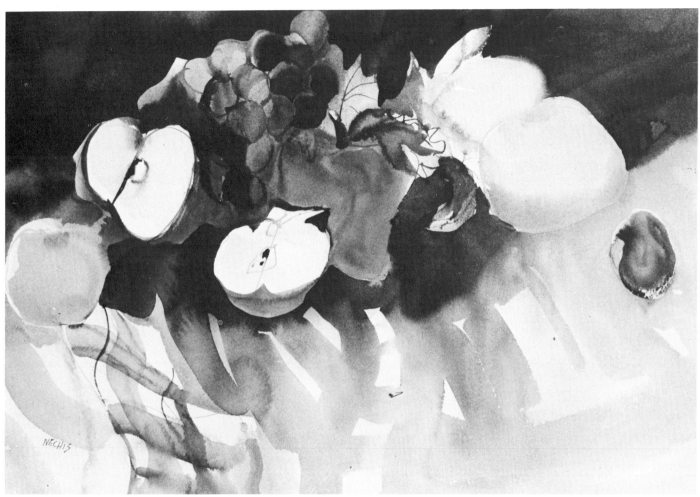

Apples, Etcetera
15" x 22"

Fruit was suggested first by establishing a midtone background; then the tablecloth striped in. A strong navy blue wash over the background dramatized the fruit shapes.

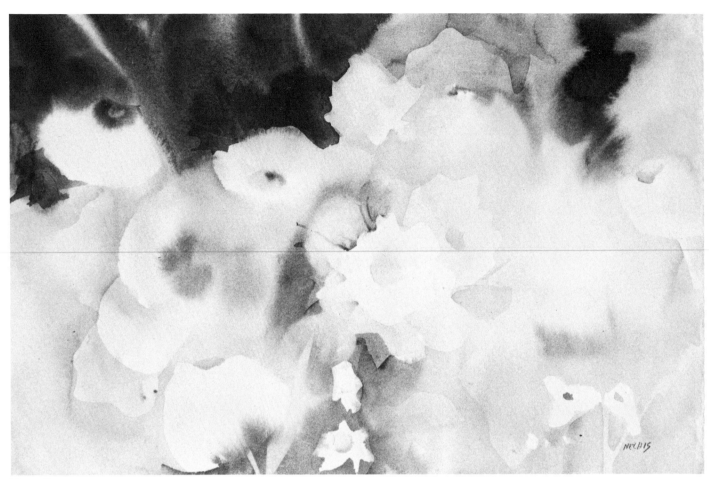

Vignette
15" x 22"

All of the forms are delineated by line painted with a rigger brush. A few soft washes were added while giving careful attention to the negative shapes of the white flower and the overall vignette.

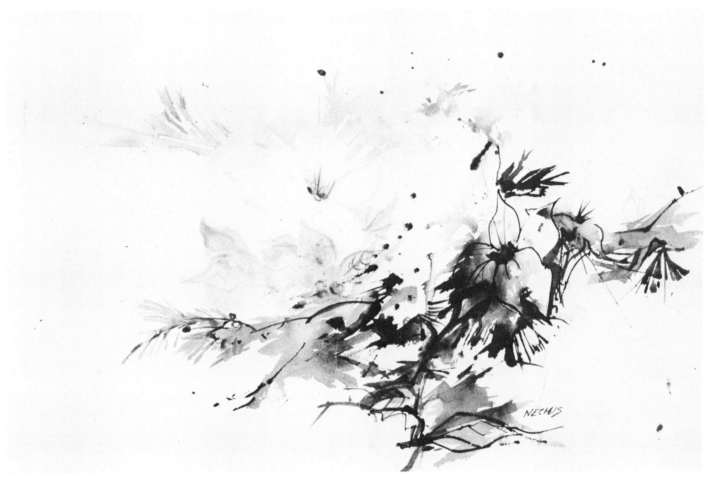

White On White

15" x 22"

This picture was painted using the same method as "On The Rocks" on page 64. The upper dark area was put in at the beginning, and sharpened at the end.

Sailboats

Technical subjects pose other problems. I have been exhibiting sailing paintings for years. Sailors (a very picky lot when it comes to finding technical flaws in boat paintings) rarely object to mine, even when I do the most outrageous things with them. (NO sailor would dare take a flyer like some of mine). This is an instance where knowing your subject thoroughly before you can abstract it is essential. I painted sailboats long before owning one, so perhaps the fascination was inherent. But after spending several seasons as foredeck crew in weekly races, I began to paint sailboats passionately. I try to paint the feeling of the wind, but I can always come up with a detail when extra interest is needed. A spinnaker pole, jumpers, spreaders, line, windows in the sail, or even waterline trim such as the boot stripe or perfect wave, can make all the difference in believability. The fact is, a technical subject needs more basic knowledge than a natural one. A good way to start would be with a lone boat at anchor, or small distant shapes on the horizon, working up to more details if needed.

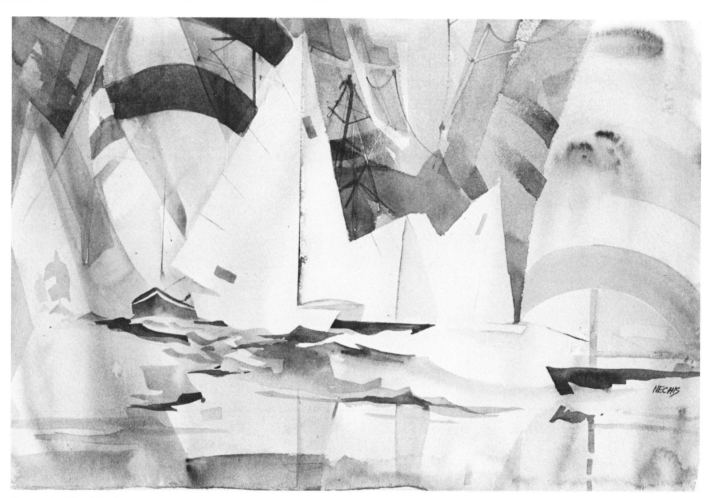

Room At The Mark
15" x 22"

The complexity of this subject is tempered by the simple white continuous sail shape. Wet washes underneath, and many layers of glaze produce interlocking shapes. The multiple varied shapes denote the feeling of tremendous activity when many boats approach a mark simultaneously.

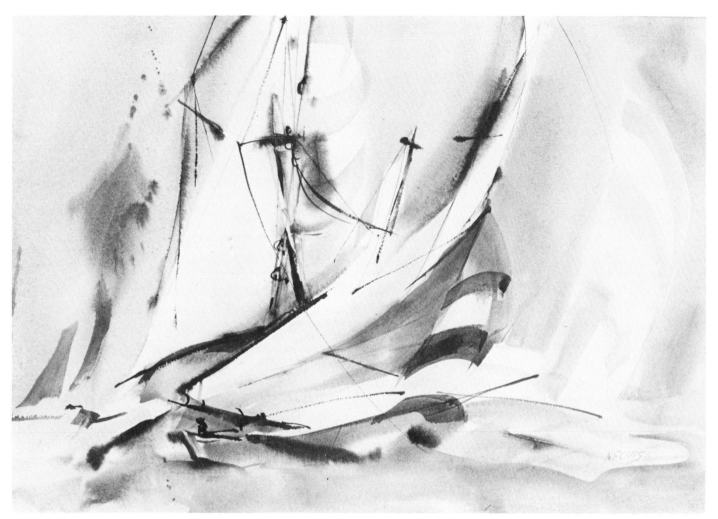

Port Tack

15" x 22"

Collection of
Dr. and Mrs. Stanley Altman,
Bedford, New York.

Looser and less structured than the previous painting, this one captures the feeling of wind in the sails and boat speed. Since many edges are soft, line is used for crispness.

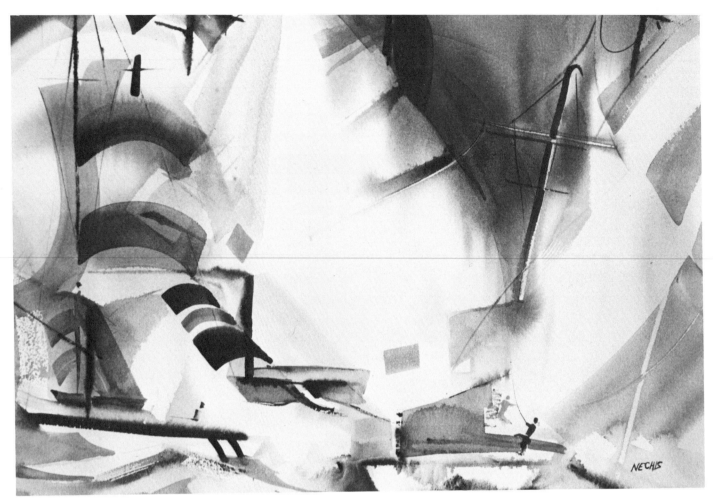

Finish Line
15" x 22"
Collection of
Mr. and Mrs. Lawrence K. Fleischman,
Dobbs Ferry, New York.

Soft washes, scraped sail shapes, and painted spinnakers emphasize a closeup of sails. The area to the left is smaller and more complex to balance the large simple shapes on the right.

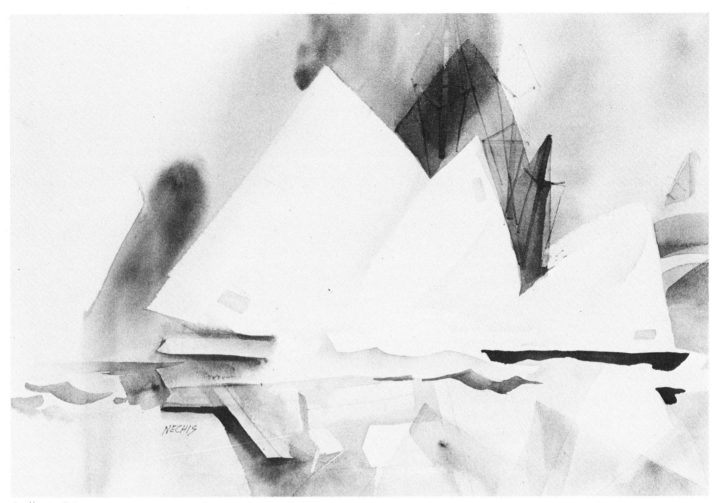

Sailboat Patterns
15" x 22"

The essence of the sailboat shape is stated with a minimum of decoration. Soft pale glazes tone the white sails to add variety to the whites.

Buildings

Buildings need a basic knowledge of perspective. I rarely pay attention to perspective rules and sometimes deliberately avoid them. Distortions can make a building more interesting. A push-pull movement can do strange things to space. Also, disregarding a constant source of light can make interesting value patterns. However, the knowledge of the basics can pull you out of trouble by signalling to you when something doesn't work. Then you will automatically make the correction. I find that the one perspective rule I disregard the least is scale. Generally, closeup details must be larger than distant ones, but I frequently emphasize something in the distance and give the foreground a brushoff. In disregarding perspective, large distortions create design interest while slight distortions tend to just look inaccurate.

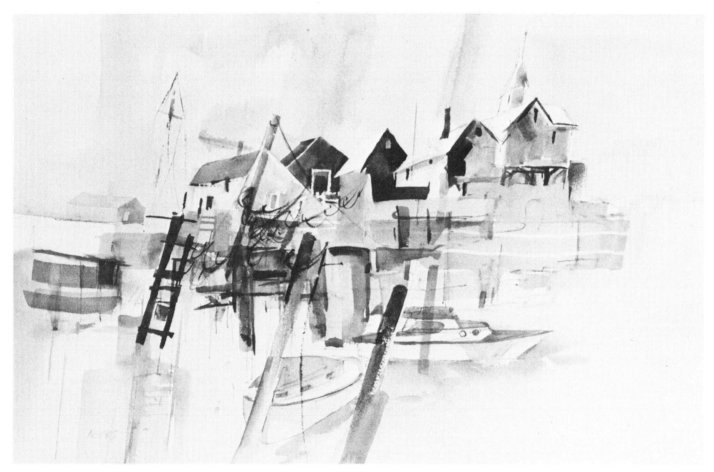

Kennebunkport
15" x 22"

Notice the arbitrary arrangement of light and dark shadows on the houses, creating a moving diagonal shape. Other areas of the picture were made to repeat this emphasis. I spent such a long time across the river from these shacks that I had to re-draw my boats. The tide had gone out and left my original drawing high and dry.

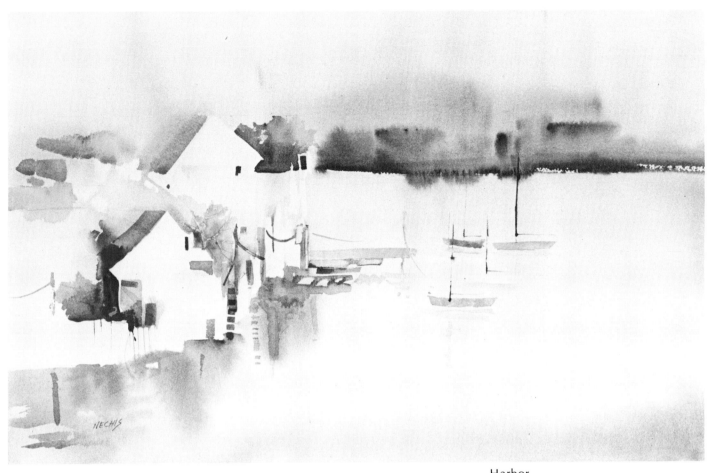

Harbor
15" x 22"

The distinguishing factor in this painting is the suggestion of white shacks where none exist. Only the two small windows and the edges of roofs suggest the subject; the viewer fills in the gaps.

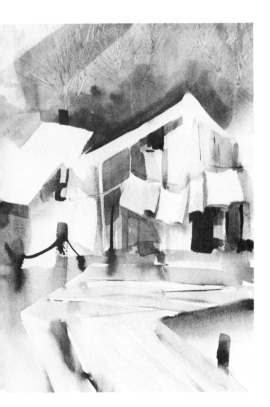

Laundry

A detail. This is a portion of another shack painting. Texture of boards on the buildings and the laundry are the details that make the subject interesting. The trees in the background were knifed through a layer of wash.

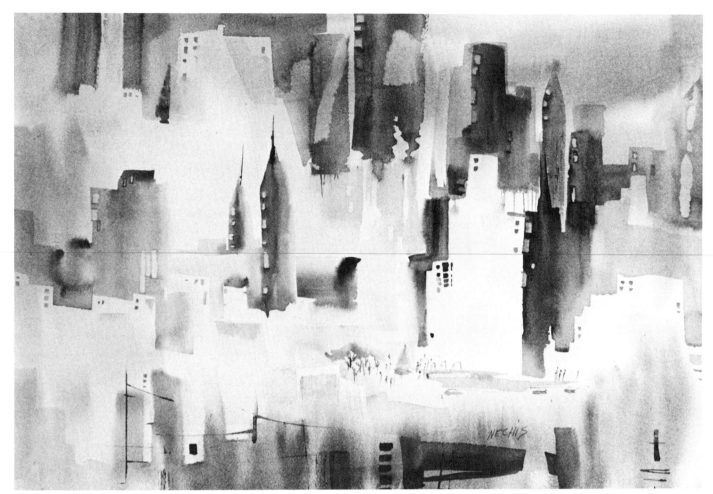

I Love New York
15" x 22"

Positive and negative glazing made this city. Darker background buildings create the shape of foreground white buildings. The shapes weave in and out, with the purest white and darkest buildings in the lower right attracting attention. This painting used a border start on wet paper, and the shapes were cut down as the paper dried.

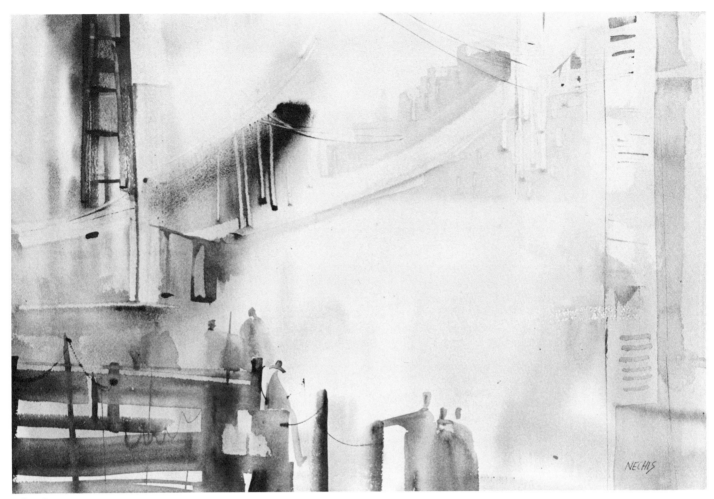

Wharf Sitters

15" x 22"

Collection of Helen Charbonneau,
Dauphin, Pennsylvania.

Wet, direct painting, fast scrapings, and a few dry accents are the characteristics of this painting. If you place your finger over the heads of the figures, all that remains are abstract shapes. The figures are illusion.

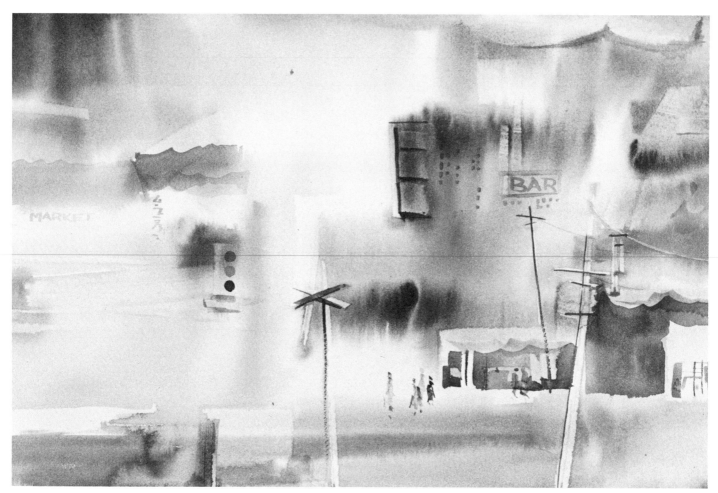

Street People
15" x 22"

Here, the city is a soft closeup. Only details are painted, without the buildings themselves. Leave out these few marks, and nothing is left. Usually a painting is defined by mass, the details are extras. This painting emphasizes the opposite, with the large shapes being soft, subtle and wet shapes of paint.

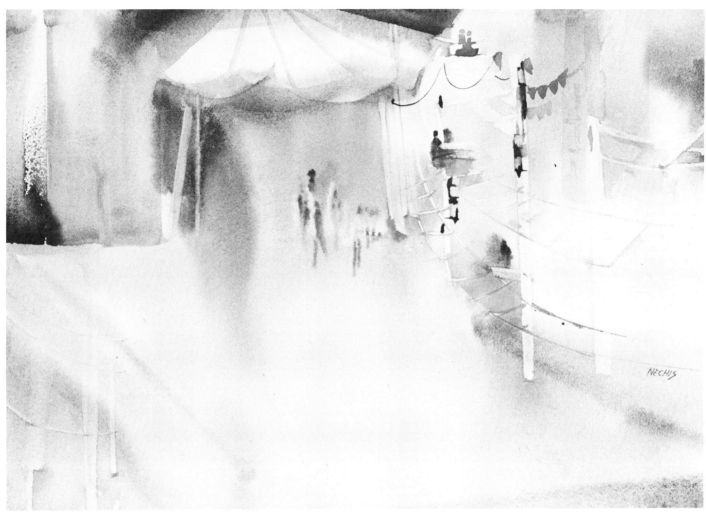

Carnival
15" x 22"

This was another demonstration in which the subject did not appear until the last few strokes although, from the start, I knew what it would be. The wet areas were painted, the amusement ride scraped out, a few knife lines and people touched in. The white shape was negatively glazed to produce a tent as the final step.

Trees

Trees can assume so many shapes. Perhaps that is why I love to paint them. Don't ask me to paint a specific kind of tree. Mine don't have names. But they are light and dark, large and small, many and few, dry, wet, textured and soft, close-up and distant, in all seasons, weather, color, and on all kinds of paper. Simple observation of nature, love of the subject, and a creative mind produce lovely effects.

A few technical points to keep in mind would be in attaching branches and planting trunks. In an abstract where I plan to suggest trees, I resist placing specific branches for as long as possible. Since I frequently turn my paper around, creating a design which works in all directions until I decide which direction to settle on, the early addition of branches will force this decision. Almost any painting can be turned upside down in the early stages. However, it is during the wet stage that I add soft wet background trees. So, decisions must be made before, not after the branches are added or they will look quite strange. Other observations I have made are that a half dozen branches on four trees is inadequate, but this number grouped in one area creates the illusion of full branches and only a few will be needed for the remaining trees. I can't recall ever seeing a painted tree branch look too long. Frequently, they look too short. So use your whole arm and gracefully extend branches. Take care to have the branches of closer trees extend in front of, not intertwined with trees placed further back on the picture plane.

Many of my trees suggest large curvilinear forms. If vertical trees are emphasized, be careful to vary their angles so that they do not exactly parallel each other. Slight variations in their relationships add interest. The more the trees, the more likely parallels will occur by chance as you consciously avoid them in one area only to produce them in another.

One design device I enjoy using is forcing the viewer's eye in a particular direction by the use of a branch. I will bring a branch out of a tree in one direction and then swing it around across the trunk or behind it.

Finally, check your trees. If they don't feel right check your yard and your reference file. Don't expect to make believable trees without both visual and technical experience.

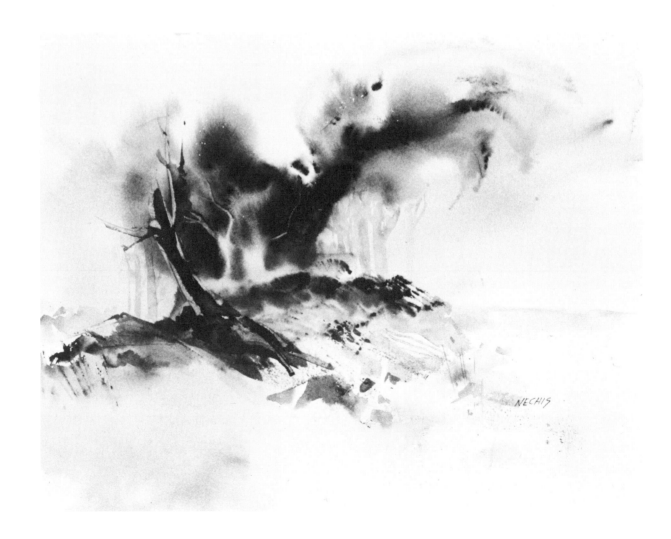

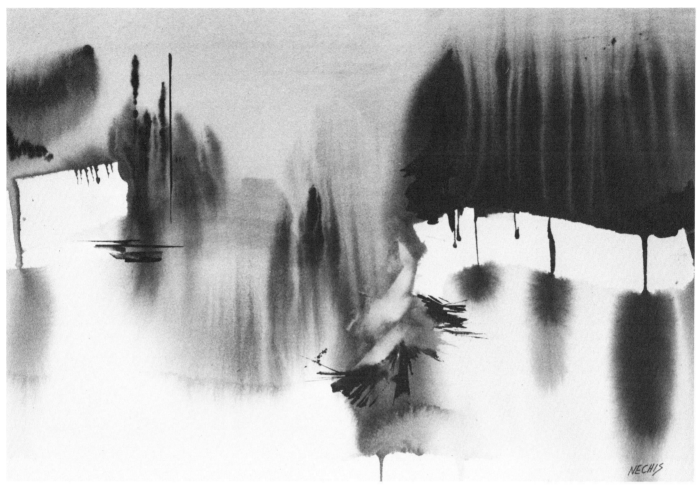

Running Wood
15" x 22"

The white areas were kept dry and
the rest was wet. Look closely at the
right and you will see three effects
generated with one stroke and the
help of gravity. The drips from the
damp area spilled over to the dry
paper creating thin lines, then balloon-
ed again as they coursed down into
another wet section. The pale lines
vertically striping the large dark mass
suggesting trees at the top right were
caused by the dripping of excess water
in the sky wash through the dark
abstract tree area.

Thicket
15" x 22"

A group of trees was intended. The
swirl of dark wine pigment placed on
dripping wet paper produced the ex-
plosion effect. Other texture was
scraped with a serrated plastic knife,
spattered and glazed.

151

Chapter 10. Presentation

This last section deals briefly with some of the problems concerning the professional growth of an artist. Many ingredients make up an artist. There are no answers but many valid differing routes to follow. I feel that it is helpful to consider some of these routes before finding yourself in the middle of the wrong trail.

The best definition I have seen for professionalism comes from Jacques D'Amboise, Dean of Dance at State University of New York, Purchase. "Professionalism is excellence, publicly tested." It is important for the artist to present himself in many areas and it takes some experience.

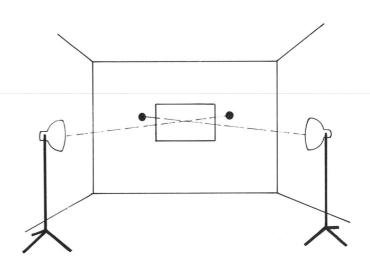

Juried Shows

This is often a first step for artists interested in building a biography and wanting to see how their work measures up in competition. When the jurying is for membership in an organization and a number of pieces are requested, it is important to show a body of work that is of the same period and feeling. It never ceases to amaze me when I sit on a jury and find perfectly acceptable painters submitting work that could have been done by three separate people. So keep your work consistent.

If you choose to subject your work to a jury, try to find out something about the jurors work or preferences in advance. Some juries will not like certain styles no matter how skilled. It is a waste of money, time and effort to submit abstracts for example to a show which exhibits only work done in a representational manner. Always submit your best work even if you feel that a show is unimportant. If it is important enough for you to enter, you should be well represented. Keep in mind several points about jurors. If a juror is expert at renderings, yours may seem quite inferior to his, so enter something he or she may not be as experienced with. A painter who concentrates on strong value contrasts may be excited by something quite different with unusual color. Open minded realists may love skillful abstractions, and abstract artists can admire skilled creative realism. It is helpful to find out the proportion of work submitted which is being accepted or which has been accepted in the past, before entering. Some artists prefer the challenge of a small number of selections, and others try for a higher ratio of acceptances.

Photography

Unfortunately, many artists, although perfectly comfortable with all aspects of painting, are often remiss when it comes to the commercial aspects of presenting themselves properly. Photography is one of the most important areas. With paintings becoming larger, and so many artists seeking space to show, galleries and exhibitions are placing increasing emphasis on color slides for preliminary screening, if not for final selection.

Through trial, error, and expert advice, I have set up a photography area in my small studio in order to record work at a moment's notice. I am not dependent on the weather and can photograph work as it is produced or before it leaves the studio. I have a record of work in galleries and glossies ready for publicity on request.

A 35mm single lens reflex camera with cable release, on a tripod is excellent for studio work. I use a Pentax K1000. Ektachrome 50 Professional film with 3200 tungsten photo floods was used for most of the color slides in Color Portfolio II. In some, the blue was too warm so I substituted Kodachrome 40 Professional film with 3400 K. bulbs. I keep a roll of each film on hand in my refrigerator, using the Ektachrome for paintings that are predominantly warm and the Kodachrome for those that are cool. I find 250 Watt bulbs are adequate. During daylight hours I use room darkening shades when I shoot. Plus X film was used for all of the black and white reproductions in this book.

When choosing slides for competitive exhibitions, project them and try to choose the one that looks the best without being influenced by the original paintings. It helps to have impartial opinions and I usually make it a family choice.

My studio is only 10' wide. Two light stands with reflectors stand, at mid height, against the side walls at 45° angles to the painting, about 5½ feet from the wall holding the art work. Since much of my work is in two sizes, I have drawn lines on the wall surface in these sizes. Round tabs of masking tape are placed in the four corners, to attach the painting to the wall. After each painting is recorded at the desired number of light readings, it is removed from the wall, leaving the tapes behind and the next painting is placed. The tapes are replaced when they no longer hold. I prefer to shoot without glass, but if a painting is particularly well framed, I pay close attention so that the floods, camera, or tripod do not reflect in the glass. A polarization filter can be used to eliminate reflections. I have also held dull black paper in front of the tripod to minimize reflection.

Color work should be bracketed with three light readings. After printing several rolls of black and white film, I found it necessary to take only two, since the light and middle range shots made the best reproductions. When shooting color slides, if the wall background is black, or a black mat is used, the slide will be ready for viewing without taping to mask out the mat, frame or wall area if it is in the slide. Mats and frames should not be photographed, only the picture area. If a mat is partially shown when the dimensions of the painting differ from those of the slide, it should be masked out in the final slide.

Slide Duplicates — I used to shoot extra color slides because duplicates usually came out darker and duller than originals. However, this is no longer the case. Recent Kodak slide duplicates made of most of the work in this book are almost indistinguishable from the originals. Duplicates of old slides came out markedly better than the originals. Finally, if your slides are not of professional calibre, hire an expert.

Photograph by Mark Friedman

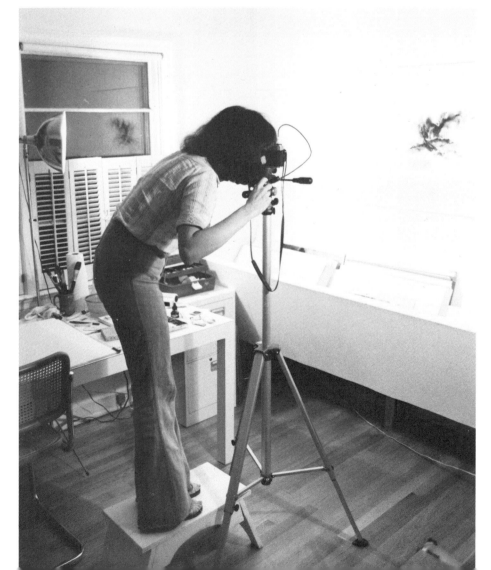

Framing and Hanging

Proper matting and framing can be a new experience of satisfaction, similar to that of completing the painting. The mat and frame should enhance the painting without calling attention to itself. Always use white or neutral mats. Color relationships are planned while the painting is in progress. If a color within the painting is used for a mat, the total proportion of that color is radically changed. Another problem occurs with colored mats in exhibiting. It calls attention to an area and may distract from another exhibitors work. I keep a variety of sample mats and liners in both warm and cool grays and varying values. I usually start with white, and if that doesn't work, try each of the others until the right choice is made. I also paint mats to freshen them with off-white Latex house paint and a roller. A white mat will tend to expand a painting, and a neutral or darker mat will enclose it emphasizing light shapes within. I use a Dexter Mat Cutter and find it invaluable. I am constantly cutting small and odd sized mats for pieces of paintings that have been saved from larger work.

Placement is of great importance to your painting. Small, intimately detailed paintings should be hung where the viewer must get close to see them such as in a hallway. Certain paintings force this intimacy. Paintings with strong design patterns look well from a distance. Paintings that are quite similar blend too much and obliterate each other when hung together. Paintings should be hung low enough to enjoy while sitting in a room and at eye level for the average viewer in hallways or galleries.

Records

I have a record of every painting I have ever sold, where, when and to whom. It was invaluable in preparing this book. Unfortunately, I cannot recall many of these paintings because some of the titles were not specific enough to evoke an image. Now I keep a photographic record of finished paintings. Even an Instamatic Camera record will refresh your memory. These records are particularly important in gallery dealings. You may deliver a dozen paintings, make a hasty duplicate list, choosing titles on the spot. Six months later on return with new paintings you may find four sold, seven to be exchanged, and "Sunshine" or "Surf" unexplainably missing. Has it been lost, stolen or sold? Did you really bring it in? Was it returned at another time? If a photo was available, it might refresh someone's memory. The painting may have been sold with no indication in the gallery's records. This is not an isolated experience. In two instances in separate galleries I did not press for payment as I could not remember the painting. In the third, I produced a photo and they recalled making a sale.

Gallery Representation

Although gallery procedures may vary in different parts of the country, it is important to establish a professional relationship with those who handle your work. I prefer to deal with galleries that I have personal knowledge of, or know of others who deal with them. If a gallery that I am unfamiliar with contacts me, I will find out whose work they handle and check with some of the other artists on their ethics, presentation, ability to generate sales, promptness of correspondence and notification of sales.

Beware of galleries that ask for fees. It is acceptable to pay for certain costs for solo shows. These vary according to gallery, some splitting costs such as invitations, postage, newspaper advertisements, and opening. If you are paying part of the rent or a fee for hanging, I would be suspicious. The best recommendation for a gallery are those that develop a clientele for your work, inform you promptly of sales, encourage you to bring in new and replace work that is not current. If gallery rent is paid by exhibitors, the staff may not have the incentive or contacts to promote your work adequately. A good gallery does not only rely on transients. They call interested clients, seek out corporate sales, and earn their commission. They should also make available to you the names of clients who have purchased your work. You have a right to keep a record of your collectors. Many of the paintings photographed for this book were borrowed from purchasers through the cooperation of galleries. In choosing a gallery, do not deal with one if the quality of work is not up to your level. Another measure of their competence is how they display paintings, are they returned in good condition, is their record keeping organized,

if a painting is lost do they make good?

After you have found a gallery which meets your criteria, you must present yourself well. It is wise to make an appointment or call first to check their procedure for viewing work. Some have specific days. Most prefer preliminary slides. If I am on a trip and see a gallery which is appealing, I will stop in and ask when it might be convenient to show my presentation book. Often I am asked if I have it with me and will produce it. The book is an 11" x 14" zipper case with plastic sleeves containing many black and white glossies, color prints, and color slide sheets of my work. If a gallery does not find your work suitable, it may be able to recommend one where your work will fit in well.

After finding the proper gallery, it is important to deal with them professionally. Don't undersell your gallery or your reputation will suffer. Keep your work within a certain price range, so that you will have some flexibility. Commissions vary from gallery to gallery but if you have a scale of prices, some can be in each range. Once a painting is priced in one gallery, it should remain at that price if shown elsewhere. Your gallery is entitled to its commission on any sale made through a gallery contact.

Destroy any paintings that are not up to your technical ability or they may come back to haunt you. All artists have early work that might serve as an embarrassment later on. But at least they were honestly done at the time and I imagine that the price reflected the quality. Do not compound the error by preserving currently inferior work and selling it cheap. Resist the temptation to keep old junk under the premise that there is a buyer for every painting.

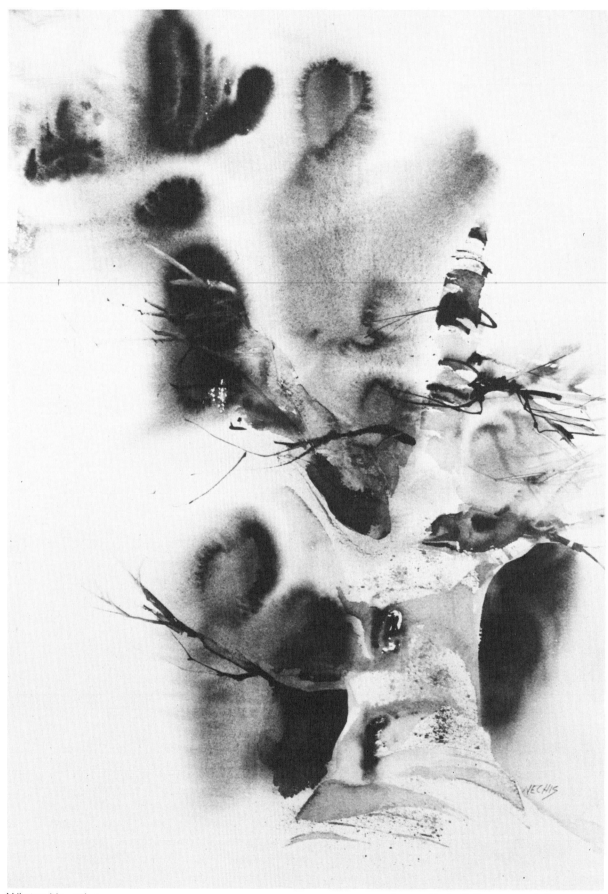

Winter Negative
22" x 15"

Opaque Naples Yellow over wash. See page 100.

Bibliography

Barr, Alfred H. Jr. (ed.) *Masters of Modern Art,* : The Museum of Modern Art New York, 1954.

Barr, Alfred H. Jr. (ed.) *Matisse, His Art and His Public,* Museum of Modern Art, 1951.

Betts, Edward, *Master Class In Watercolor,* Watson-Guptill Publications, New York, 1975.

Brooks, Leonard, *Painting and Understanding Abstract Art,* Van Nostrand Reinhold Company, New York, 1964.

Brooks, Leonard, *Watercolor — A Challenge,* Reinhold Publishing Company, New York.

Bush, Susan, *The Chinese Literati On Painting,* Harvard University Press, Cambridge, Massachusetts, 1971.

Clark, Kenneth, *Landscape Into Art,* John Murray Ltd. London, 1949.

Crispo, Andrew, *Ten Americans: Masters of Watercolor,* Andrew Crispo Gallery Catalogue, New York, 1974.

Franc, Helen M., *An Invitation To See,* The Museum of Modern Art, New York, 1973.

Graves, Maitland, *The Art of Color and Design,* McGraw Hill Book Company, New York, 1951.

Realites, *Impressionism,* G. P. Putnam's Sons, New York, 1971.

Read, Herbert, *A Concise History of Modern Painting,* Frederick A. Praeger, New York, 1959.

Reep, Edward, *The Content of Watercolor,* Van Nostrand Reinhold Company, New York, 1969.

Reynolds, Graham, *A Concise History of Watercolors,* Harry N. Abrams, Inc., New York, 1971.

Whitney, Edgar A., *Complete Guide to Watercolor,* Watson-Guptill New York, 1965.

Index